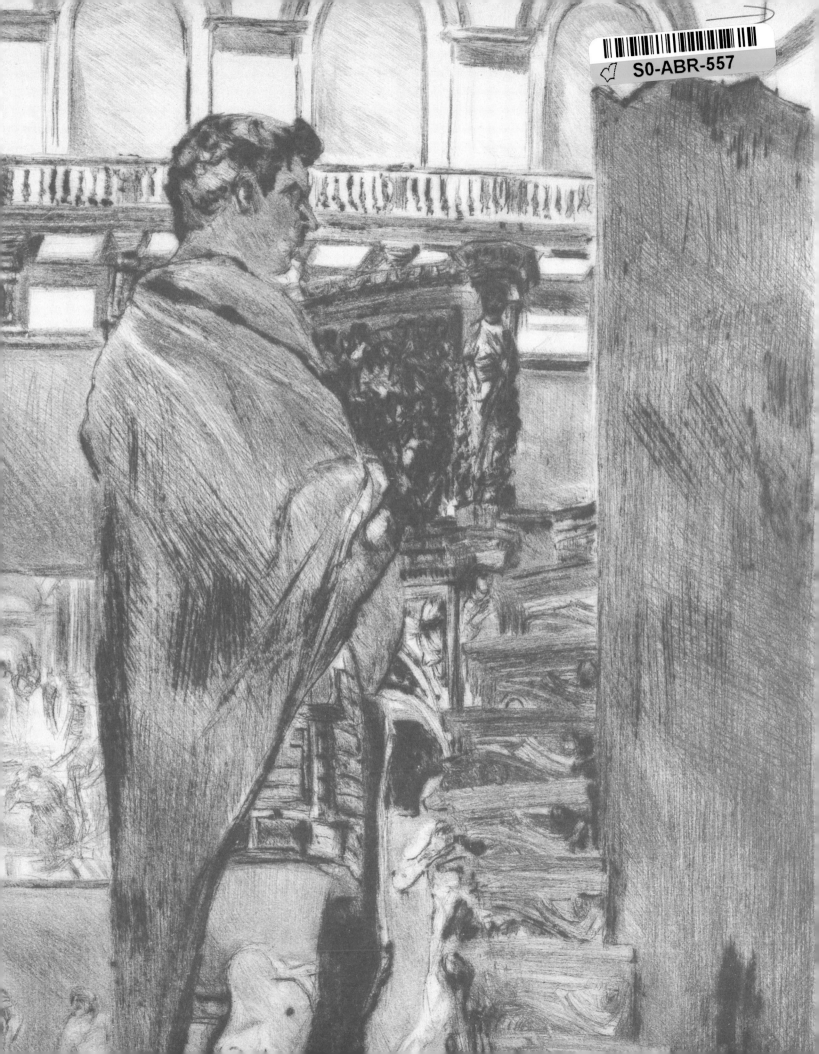

Arturo Di Stefano

Arturo Di Stefano

John Berger

Michael Hofmann

Christopher Lloyd

MERRELL

First published 2001 by Merrell Publishers Limited

'Night Train to Rome' © 2001 John Berger
'Arturo Di Stefano' © 2001 Michael Hofmann
'An Appreciation' © 2001 Christopher Lloyd
'Envoy' © 2001 Arturo Di Stefano

Illustrations © 2001 Arturo Di Stefano, with the exception
of pl. 44 © National Portrait Gallery, London

Produced by
Merrell Publishers Limited
42 Southwark Street
London SE1 1UN

Distributed in the USA and Canada by
Rizzoli International Publications, Inc.
through St Martin's Press, 175 Fifth Avenue,
New York, New York 10010

British Library Cataloguing-in-Publication Data
Berger, John, 1926–
Arturo Di Stefano
1.Di Stefano, Arturo, 1955– 2.Painting – England
I.Title II.Hofmann, Michael III.Lloyd, Christopher, 1945–
759.2
ISBN 1 85894 151 2

Edited by Iain Ross
Designed by Isambard Thomas

Printed and bound in Italy

Dimensions of works are given first in centimetres,
then, in square brackets, in inches. Height precedes width.

COVER: *Italian Cast Room, Victoria and Albert Museum
(Laocoön),* 1995 (see pl. 47)
PAGES 2–3: *San Rocco, Venice,* 1990, oil and wax on linen,
166.3 × 196.8 [65½ × 77½], collection of Mr and
Mrs J. Farmer
FRONT ENDPAPER: *Italian Cast Room, Victoria and Albert
Museum,* 1997, drypoint, 22.2 × 29.8 [8¾ × 11¾], collection
of the artist
BACK ENDPAPER: *Italian Cast Room, Victoria and Albert
Museum,* 1997, aquatint, 22.2 × 29.8 [8¾ × 11¾], collection
of the artist

Pls. 3–5, 8 photographed by David Godbold
Endpapers, illus. pp. 8, 76, pls. 1, 2, 36, 38–43, 45, 47–69,
 70–74 photographed by Matthew Hollow
Pls. 14, 26, 27, 29, 32 photographed by John Jones
Pl. 44 photographed by National Portrait Gallery, London
Pl. 46 photographed by National Museums and Galleries
 on Merseyside
Pls. 30, 34 photographed by Prudence Cuming Associates
Pl. 37 photographed by Gareth Winters
Illus. pp. 2–3, 34, pls. 6–7, 9, 10–13, 15–25, 28, 31, 33, 35
 photographed by Edward Woodman
Photograph of Arturo Di Stefano on p. 120 © Verdi Yahooda

Arturo Di Stefano's work is represented by
Purdy Hicks Gallery
65 Hopton Street
Bankside
London SE1 9GZ
www.purdyhicks.com

Acknowledgements
The artist and the Directors of Purdy Hicks Gallery would like
to express their gratitude to the authors for their essays and
to the staff of Merrell Publishers, in particular Hugh Merrell,
Matt Hervey and Iain Ross, for their enthusiasm in nurturing
this project to fruition. Finally, the artist would like to thank all
those who have supported him over the years with their help,
encouragement and belief. This book is dedicated to them.

This book has been published with the generous support of:
Neil Addison and Susan Hall
Arthur Andersen & Co.
Sarah Bates
Bob and Elisabeth Boas
Robert and Andrea Brown
David and Anne Burnett
Clifford Chance
Richard and Corin Cotton
Andrew and Jennie Dalton
Tim and Emily Fancourt
Vernon and Angela Flynn
Tim and Violet Hancock
Alistair and Rebecca Hicks
Peter and Maria Kellner
Andrew and Josie Law
Paul Liss and Sacha Llewellyn
Guy and Rachel Marshall
Penny Mason and Richard Sykes
Lord Milford
Richard and Chris Morse
Midge Palley
Julien and Bea Prevett
Marie-Louise Rossi
Joe and Shirley Rubin
Stephen Rubin and Jayne Purdy
Alex Woodthorpe

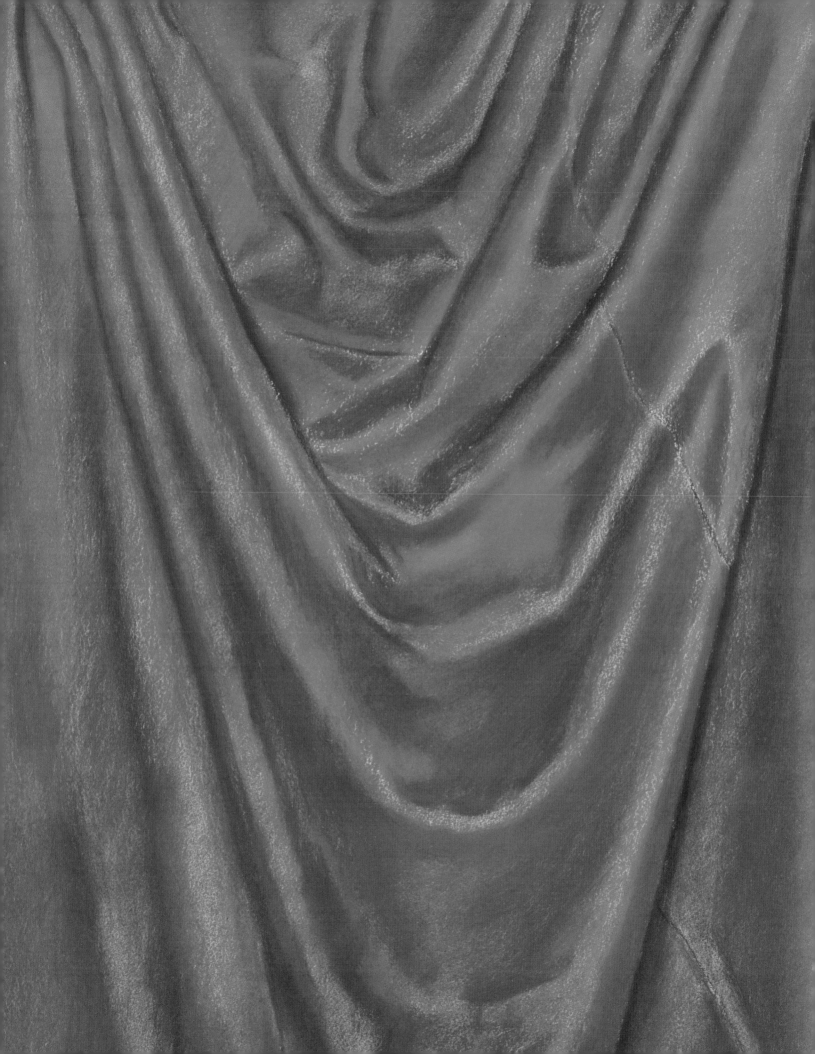

JOHN BERGER

Night Train to Rome

Arturo,

Today it's Sunday and I'm not working, so I can write you a letter. All week I've been working on a story about meeting my mother in Lisbon. She was never, I think, there, and she died fifteen years ago, aged ninety-four. And yet I find her there today; anywhere and everywhere, behind the tiles, the famous azulejos. This morning I sit at the same table, surrounded by reproductions of your paintings and prints, which make me want to swap stories with you. They speak to me a lot, the images you make. As if our fathers, or maybe grandfathers, were sleeping-car attendants on the same night train to Rome.

In certain old shops – before supermarkets and mass packaging – the women or men who served were experts in wrapping. The purchase could vary from sliced ham to a pair of woollen gloves; it might even be a book. The fascination (and the reassurance) lay in watching how they placed the object, how they folded the paper many times, the deftness with which they manipulated the string or ribbon before tying it, and the last pat they gave to the packet with the palm of their hand before handing it over. Remember? The paper on which we draw or write is like theirs, no? The so-called act of invention, it sometimes seems to me, is the act of wrapping with love.

Titian's glazes? Cézanne's contours? Don't they do that?

You are very cunning as a painter. I prefer 'cunning' to 'skilful', though skilful you are too. Skill, once acquired, fortunately remains; cunning has to be continually refound or invented. David Attenborough tells of a special type of crow in São Paulo. It eats a kind of walnut. Yet how to break the nuts open? Of course the crows try dropping them from a certain height on to concrete. It doesn't work very well – perhaps because they bounce. So they try something else. They drop their nuts on to a pedestrian crossing by a set of traffic lights on a street where there is heavy traffic. The vehicles run over the nuts, while the crows wait on the pavement until they see the pedestrian lights turn green. Then they hop on to the road with the pedestrians and fetch their split-open nuts. Do you recognize that cunning?

Red Cloth (*detail*)
1994

Pastel on paper
76.2 × 56.5 [30 × 22¼]

Your palls, your shrouds, your held-up sheet, your homage to Veronica – all this entrains symbols, very ancient ones, mythological references, allegory. Yet before all this, before the labyrinth in which we can get lost (which is what we want to do), isn't there something simpler, something to do with touch? Photography begins with the eye; painting, I believe, begins with the hand. What kind of touch intrigues you? A touch from the other side, the inside, of a wrapping? I'll try to make this clearer by using an example not from art history, but from daily life.

The experience of lying in bed in the morning and watching the loved one you have spent the night with dress. The opposite of pulling off each other's clothes and throwing them on the floor. The opposite of disclosure. The opposite of at last arriving – every time as if it were the first. The opposite. You lie there and you watch the body you love being covered, being hidden again. Yet in this there is a sweet, mysterious, covert pleasure, because you watch the now pulled-on clothes being moulded by the body, you watch the substance of the limbs or torso or hips pressing against their covering, against their dress, and the touching of these two surfaces confirms your own body's memory of touching that other body all night long. This is what I mean by a touch from the inside: it is something like what a hand feels inside a glove.

Isn't this the secret of your wonderful portrait of Jan (pl. 24)? Or, anyway, one of its secrets. The painting is not about looking at the surface of her pearly pyjamas; it is about their invisible other side where they are touching her body. Her face and neck and wrists and hands, which are visible, emphasize what is being touched and hidden. Then your cunning comes in, for it's about more than that. The whole painting is about her coming forward, her approach. This is why she's placed as she is. In a moment her right foot will bring its slipper nearer and over the painting's threshold. Yet more important still is the almost perceptible inclination of her body against the front of her pyjamas. This inclination is conveyed with such reticence and tact and sureness that it breaks the painting's heart and turns it into a double portrait of love (single portraits of love don't exist).

Imagine an exchange of love letters, neither sent by e-mail nor written on paper. They are torn pieces of cloth, each one different, each one slipped into an envelope with the other's address written on it. They are not signed.

The master of the invisible interface between skin and dress was Goya (in about a dozen paintings?). Otherwise, the perception of this particular form of touching is as rare in painting as it is common in love.

I'm writing this letter with a Sheaffer pen and so-called jet-black ink. I use the same when I draw – above all because I like the black, full of purples that speak of the wine-dark sea. The ink of shadows. When writing, words, too, cast shadows, and, unless you remember this, you will never achieve clarity. Clarity depends upon the placing of the shadows – see your *Chiaroscuro* (1985).

To come back to the touching-from-the-far-side, or what I call the interface.

In the portrait of Jan this is clearly and directly related to the emotions and sensations I have tried (clumsily) to describe. But a similar pressure of touching is there, even if more mysteriously, in other paintings. (The fact that you often paint on linen – which is also a material for clothes and sheets – is, as they say, no accident.) A touching-from-the-far-side is tangibly there in *The Cumaean Sibyl* (pl. 7), in *The Shroud of Penelope (Rove)* (pl. 8), in *Nessus: the arrow bred in the bone* (pl. 10), in *Pall: After John Donne* (pl. 4) and, particularly, in *Bather* (pl. 23).

An overcoat hanging on a bedroom door. It stirs in the dark. Searches for a pair of shoulders. And ambles towards the bed.

You often use photographs – sometimes legendary photographs – yet this is incidental to what you achieve, for in each case you translate the optical traces of photography into traces of a touching: a touching coming from behind, against the surface of the seen image.

This is what I want to say this afternoon – the morning has already gone by – about the eloquence of the space created in the images of your paintings scattered around me on this table.

Tonight, above the mountains outside, the stars are particularly bright, which is strange, for it is not at all cold. They make me think of a sentence written by Simone Weil: "Stars and blossoming fruit-trees: utter permanence and extreme fragility give an equal sense of eternity."

Tomorrow I'll try to say something about how I see not space but time in the same images. May God help me.

It's odd, because your paintings featuring people are about space more than about lived time; and your paintings about places are more about time than about the lie of the land. I oversimplify, yet that's the condition of writing letters; the envelope and the delay and the postman take care of the rest.

Streets, railway lines, arcades, water. As you know, the French for rear-view mirror is *retroviseur*. And that's the key word for me, looking at your places. A *retroviseur*, ideally, on a motorbike. It could be in a car, but that's not so good, for the mirror is already reflecting through a framed window, whereas on a bike it's unprotected in the air rushing past it.

Your places are all seen in a *retroviseur*: they are images of what one has passed through and is leaving behind. The speed at which one is travelling is the speed of time passing, which is a variable; it depends on whether time is accelerating or braking. Whatever the speed, the place is receding, and some of what was there when you rode through it has already gone, gone in the opposite direction. You have come out of the arcade or the street or the tunnel and, at the far end, somebody or something has just vanished.

Places in painting are usually depicted as points of arrival. Breughel. Constable. Courbet. Kossoff. (Maybe Turner is the exception.) Your places are points of departure. *Hotel Splendide* (pl. 41). This remains true even when they are interiors. We are not going to walk up that staircase in front of us; we have just come down it. We are not going to open that door; we have just shut it. Which is why the word for W E L C O M E on the doormat is upside down.

The painting you call *Adit (Camera Obscura)* (pl. 52) recalls the entrance to a coal mine where your father might have worked. But in this picture he has just come up, he has finished his shift, and he's leaving, isn't he? If we saw him, his face would be black.

On to a bike again, for then it becomes less simple. On a bike you are vulnerable. Which is why you look, observe, all the while. Your own eyes are your guardian angels, nothing else. You look ahead and around and back. And what you see in the *retroviseur* is what you once saw ahead and then, a moment later, what you saw around you. And now it's behind you. *Orange Street, WC2* (pl. 40).

The image of what you are leaving behind becomes continuous in your mind with the image of what you are approaching. Your gaze is constantly flickering between the two – especially when there's a lot of traffic. And the faster you're driving, the quicker the flicker.

Why tell you this? What the hell has it to do with reading or painting or printmaking? The image in the *retroviseur* of what's behind the pilot, of what he is drawing away from, is inseparable for him from the image of where he is going and what is approaching him. The place he sees in the *retroviseur* is both itself and, also, an announcement of an *elsewhere*.

William Brown Street, Liverpool (pl. 37).

When you make your counterproofs and print them on paper, isn't it the *retroviseur*, the mirror, you're acknowledging?

The elsewhere, the invisible places ahead, mean what? They mean *the time it will take to get to them*. Your painted places of departure exist in the immediate time-to-come before the next place, which we can't yet see. This time gap may be a few seconds or a fraction of a second, depending upon the speed. I'm crazy? Pirandello could help.

Couples walking hand in hand. Striding forward. Held hands still. Each is offering the other their own handprint.

Maybe your latest paintings combine (among many other things; no list can exhaust a proper work) the two pressures, the two tendencies I've been

talking about: the slight inclining forward of the figure-to-be-noticed, and, at the same time, the leaving behind in the *retroviseur*.

In your imagination (as I imagine it) everything is either pushing gently closer or receding. And I find this dialectic moving and touching – in all the senses of those two words. The way your imagination works evokes what happens in the act of creation itself. Something approaches pleading to be noticed, a dialogue takes place, a dialogue during which the unexpected may be said, and then one has to move on. Unfaithful as Mercury.

Pier (pl. 65); *Coram's Fields* (pl. 64); *Luccan Pool*. The figures in these places are members of your family or friends. In *Pier* there's you yourself, very close to the others, and leaving fast. What I perceive in these paintings is again to do with time and with human presences shrouded behind a surface. Yet here the surface isn't linen or cloth, but videotape. Each figure is from a video of her or his life. And their bodies press or lean very lightly against the tape so as to be more visible. There are as many videos as people, and they are all in a place we are about to leave.

Furthermore – and this is the crow's cunning! – each video has been shot at a different speed, in accordance with the person's temperament or history or age. No two of them synchronize perfectly. They offer gestures to one another, yet they cannot quite touch, since their times are different. They are aware of this. They suffer a small sadness, and this small sadness is evidence of their great love.

One of the things my mother told me in Lisbon, Arturo, was: Don't forget, John, it's in discretion that you find some of the sharpest pain in this life.

Our grandfathers. Coaches 17 and 18. Early morning. In the first light the Roman buildings look flat – as if printed on silk covering the corridor windows. The two men have already opened the blinds. Now they are going from berth to berth collecting the tousled sheets, the thin pillows still indented from the particular weight of a head. Each sheet, before they whisk it off, lies rumpled in a different way. They stuff the sheets and pillowcases into Bordeaux-red sacks. They work very quickly. Then they carry the two sacks to the end of Coach 18, which happens to be the last coach of the train. There they shove the sacks on to a special rack, above where they keep the coffee cups and biscuits. The little cabin smells strongly of coffee.

For a brief moment each of them goes out into the corridor, and, glancing through the window of the locked back door, watches the rails receding at a speed of 110 km per hour. In a minute – the train has already passed the Via Appia – they will put on their uniformed jackets. Their caps they will leave on their hooks until they start helping the passengers with their luggage down on to the platform. Their caps command respect and encourage tips.

Abbracci,
John

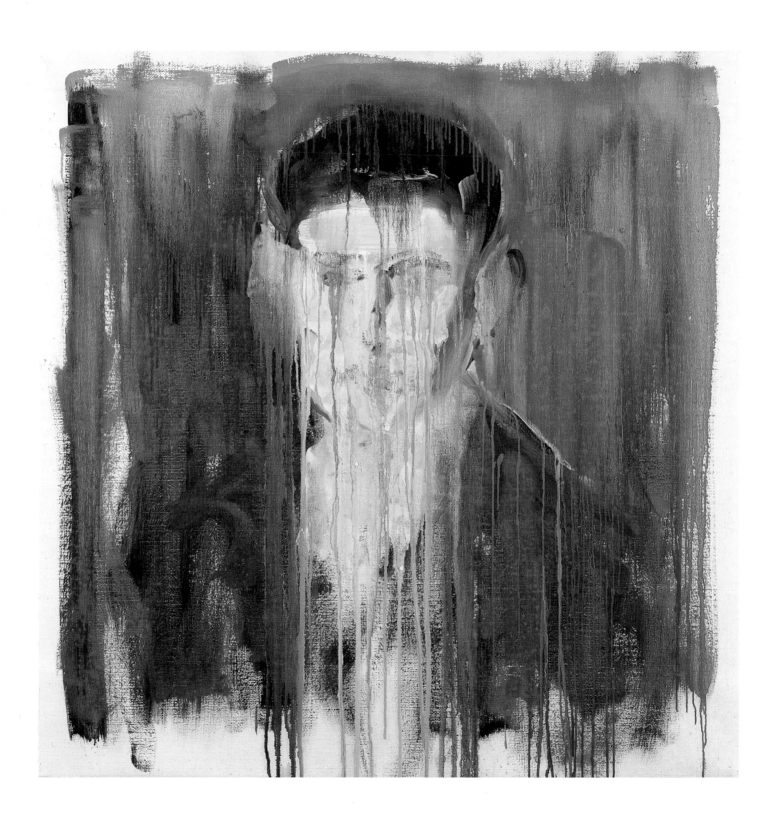

1
Sudarium: Kafka
1986

Oil on jute
95.2 × 95.2 [37½ × 37½]

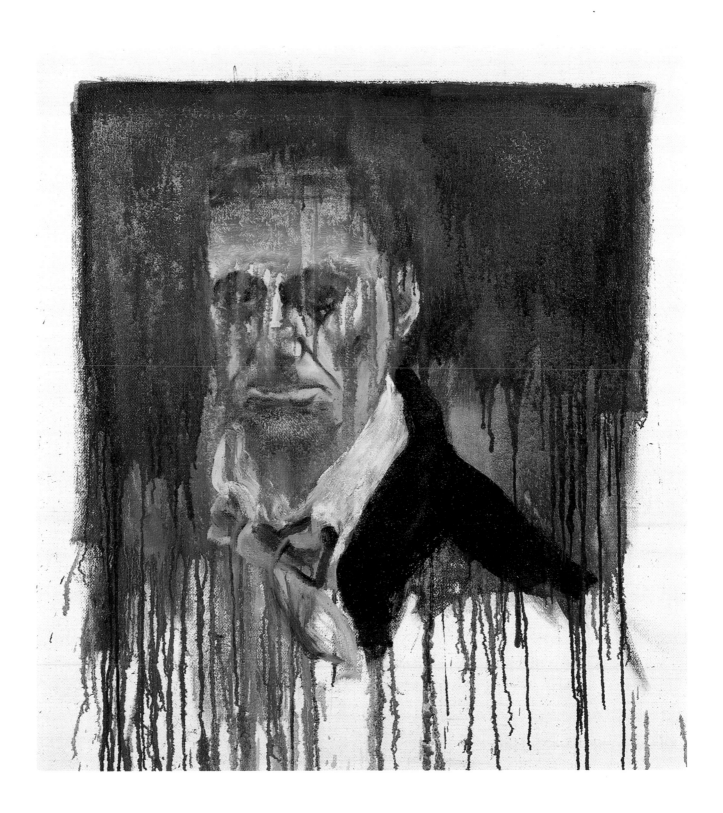

2
Sudarium: Baudelaire
1986

Oil on jute
96.5 × 91.4 [38 × 36]

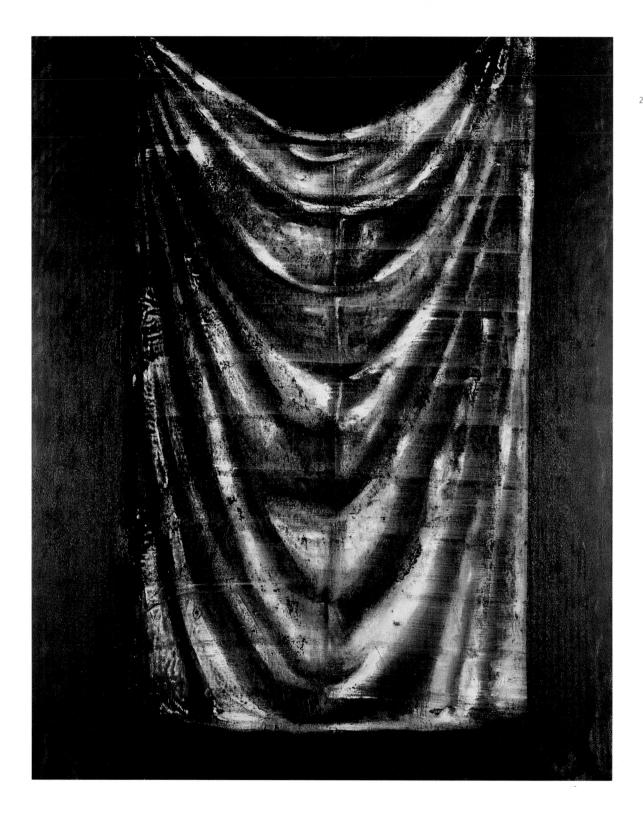

3
Shroud
1987

Oil on linen
203.2 × 166.3 [80 × 65½]

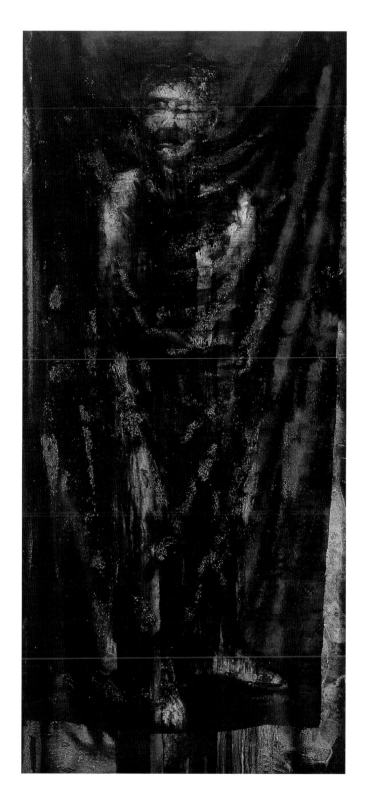

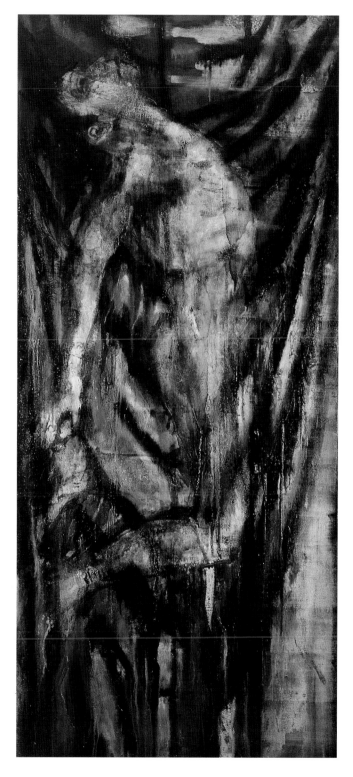

4
Pall: After John Donne
1987

Oil on linen
213.3×97.8 [$84 \times 38\frac{1}{2}$]

5
Pall: Ixion
1987

Oil and wax on linen
213.3×97.8 [$84 \times 38\frac{1}{2}$]

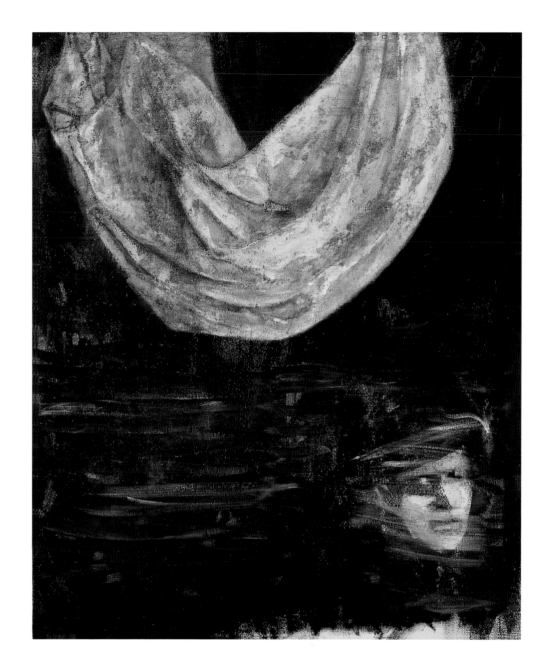

6
Carphology: Tenebrae
1988

Oil on linen
152.4 × 127 [60 × 50]

7
The Cumaean Sibyl
1988–89

Oil and wax on linen
214.6 × 98.4 [84½ × 38¾]

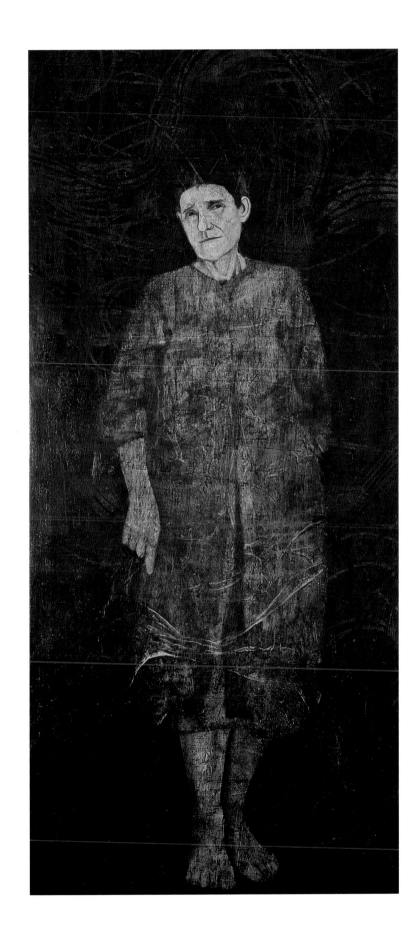

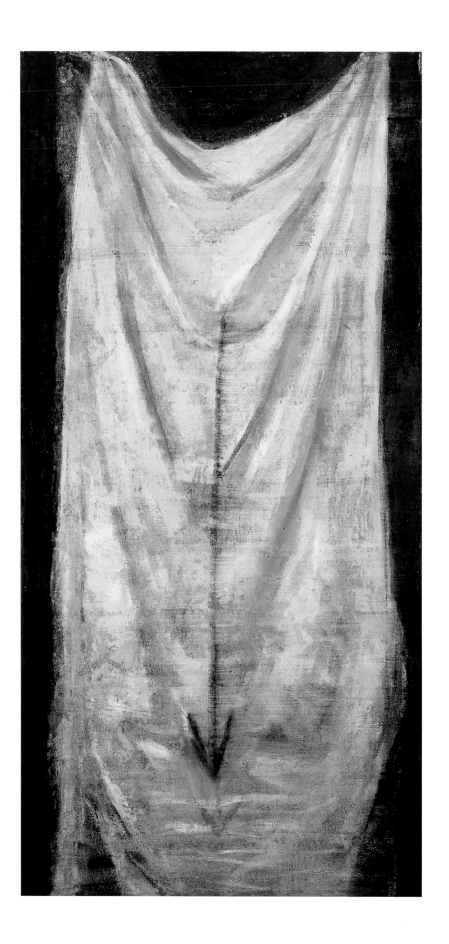

8
The Shroud of Penelope
(Rove)
1988

Oil on linen
177.8×88.9 [70×35]

9
Untitled
1988–89

Oil on linen
210.2 × 98.4 [82¾ × 38¾]

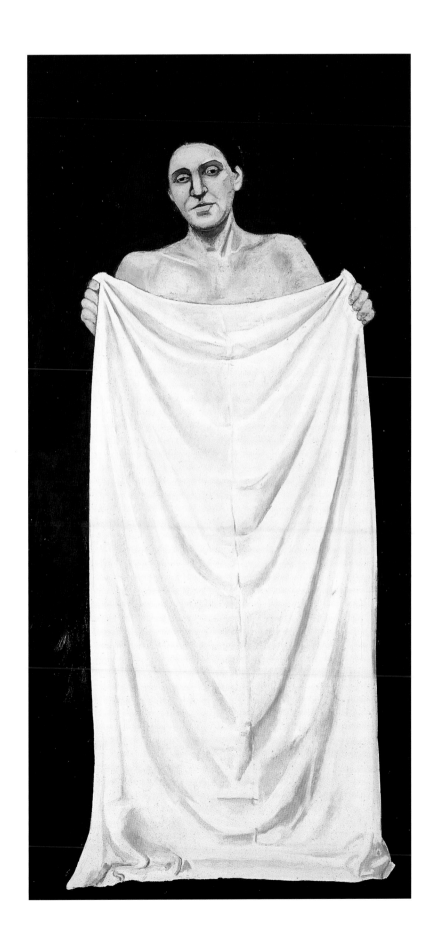

10
Nessus: the arrow bred
in the bone
1988–89

Oil and wax on linen
214.6 × 98.4 [84½ × 38¾]

11
Mnemosyne
1989

Oil and wax on linen
205.7 × 80 [81 × 31½]

12
Via Roma, Turin
1990

Oil and wax on linen
148.6×200.2 [$58\frac{1}{2} \times 78\frac{5}{8}$]

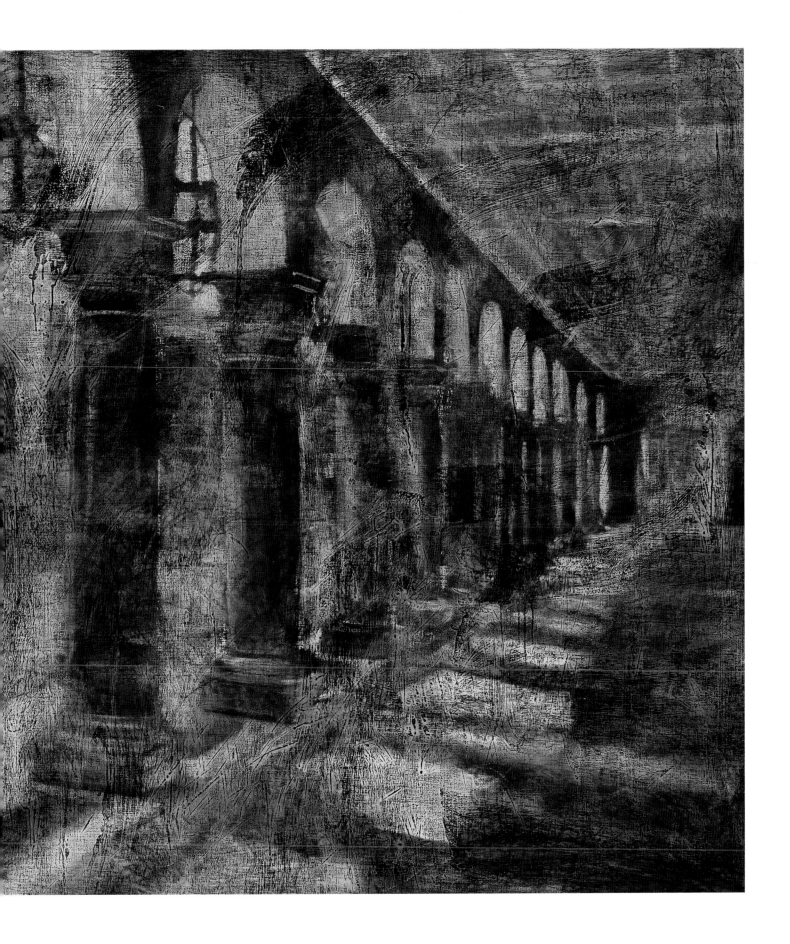

13
St Paul de Mausole
1990

Oil and wax on linen
207.6 × 145.4 [81¾ × 57¼]

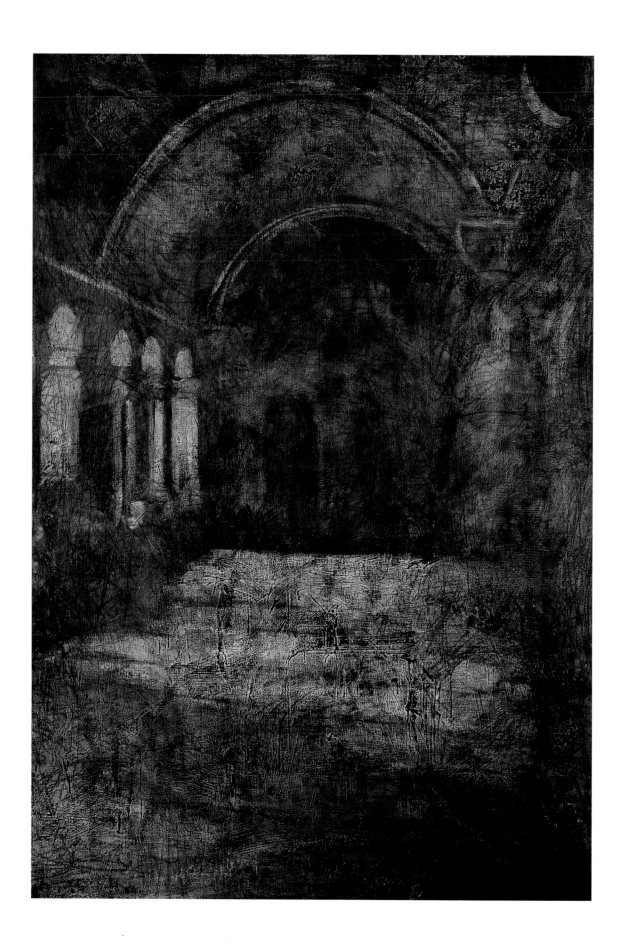

14
San Marco, Venice
(Acqua Alta)
1991

Oil on linen
200.6 × 198.1 [79 × 78]

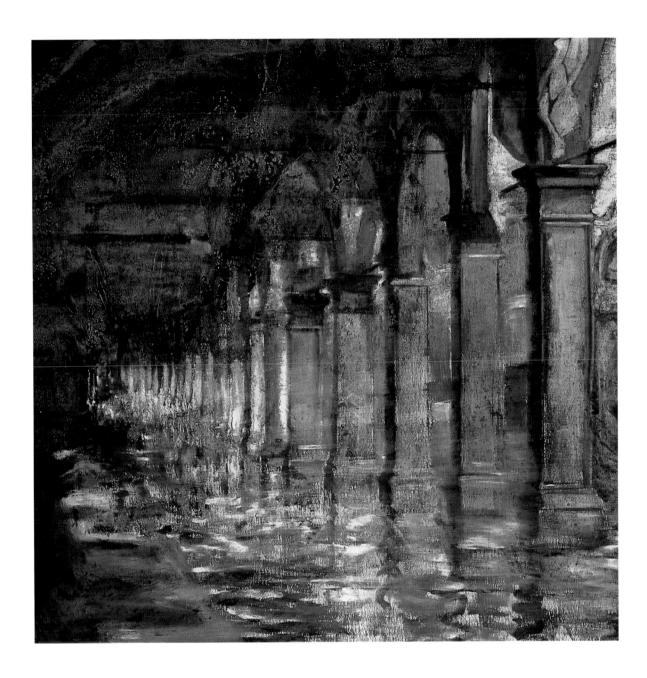

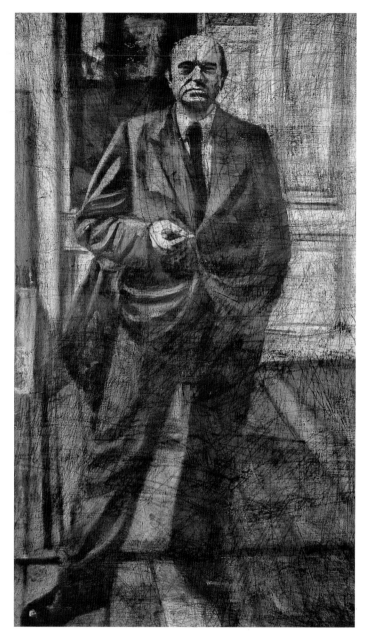

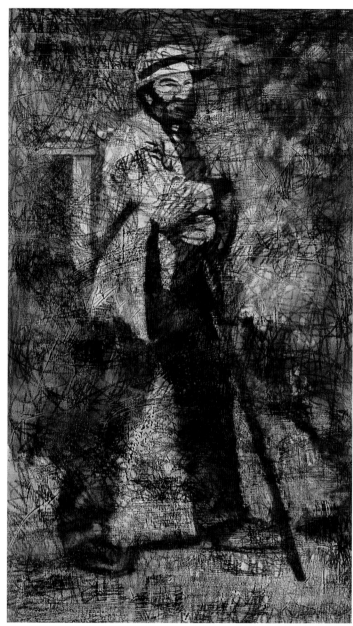

15
Beckmann
1990

Oil and wax on linen
168.9 × 96.5 [66½ × 38]

16
Cézanne
1989–90

Oil and wax on linen
168.9 × 97.8 [66½ × 38½]

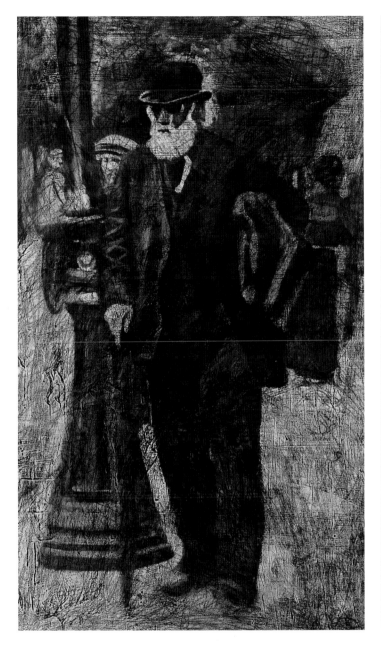

17
Degas
1990

Oil and wax on linen
168.9 × 97.8 [66½ × 38½]

18
Malevich
1990

Oil and wax on linen
168.9 × 97.8 [66½ × 38½]

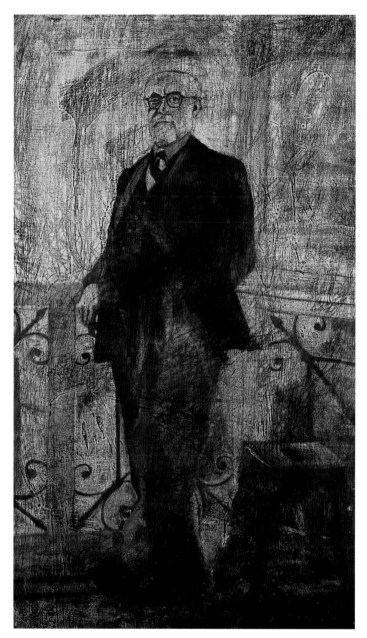

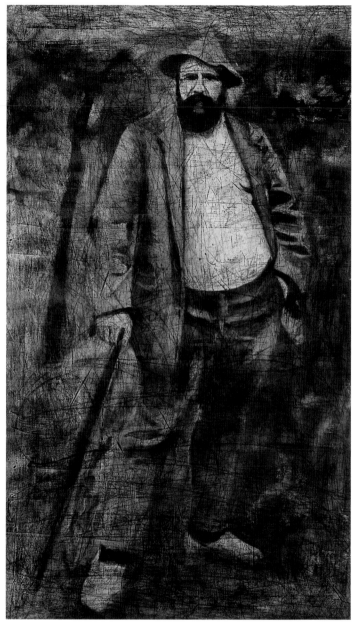

19
Matisse
1990

Oil and wax on linen
168.9 × 97.8 [66½ × 38½]

20
Monet
1990

Oil and wax on linen
168.2 × 97.8 [66¼ × 38½]

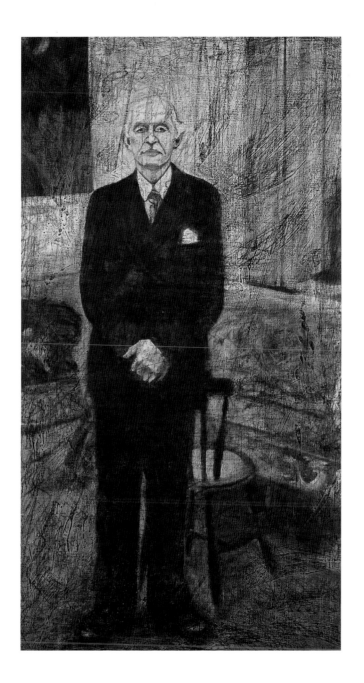

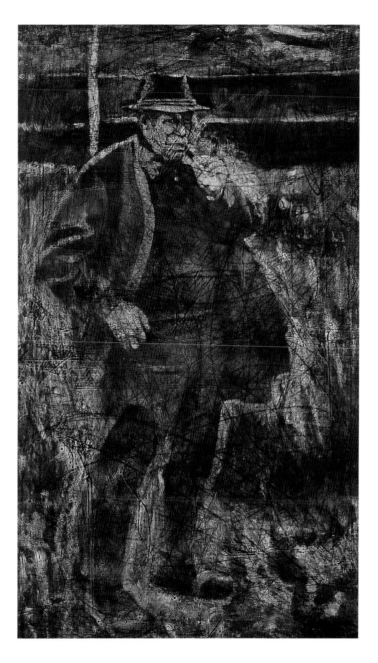

21
Munch
1990

Oil and wax on linen
168.9 × 90.1 [66½ × 35½]

22
Picasso
1990

Oil and wax on linen
170.2 × 99 [67 × 39]

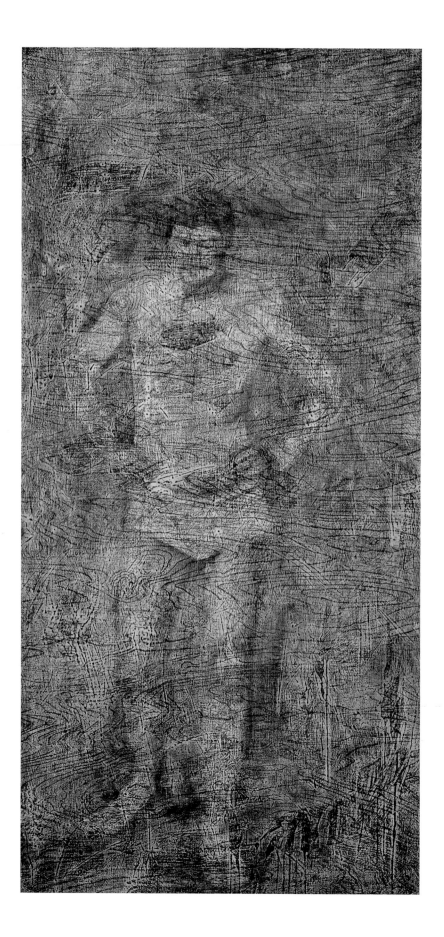

23
Bather
1990

Oil and wax on linen
186.4 × 91.8 [73⅜ × 36⅛]

24
Portrait of Jan Di Stefano
1991–92

Oil on linen
194.3 × 97.5 [76½ × 38⅜]

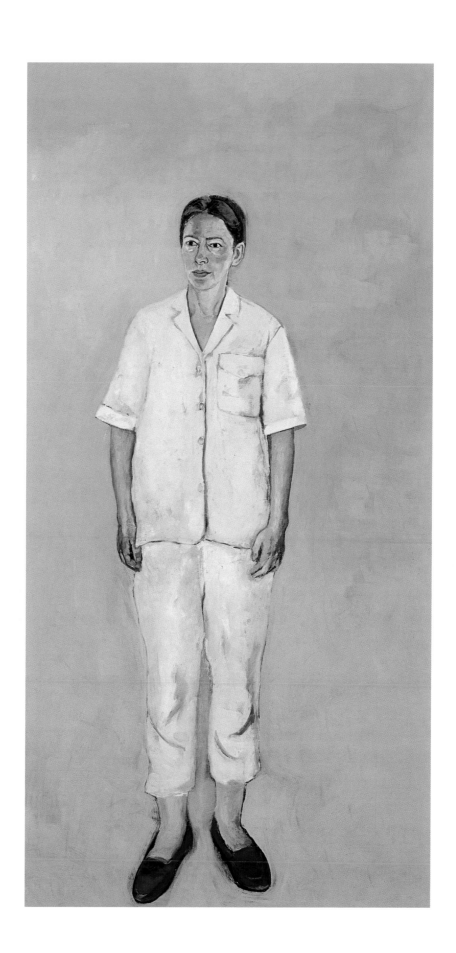

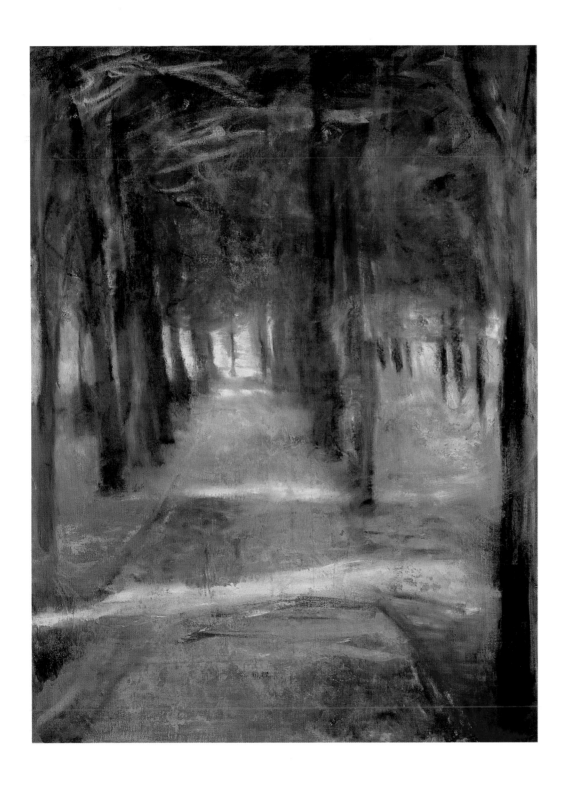

26
Tuileries Gardens, Paris II
1991

Oil on linen
189.8 × 144.1 [74¾ × 56¾]

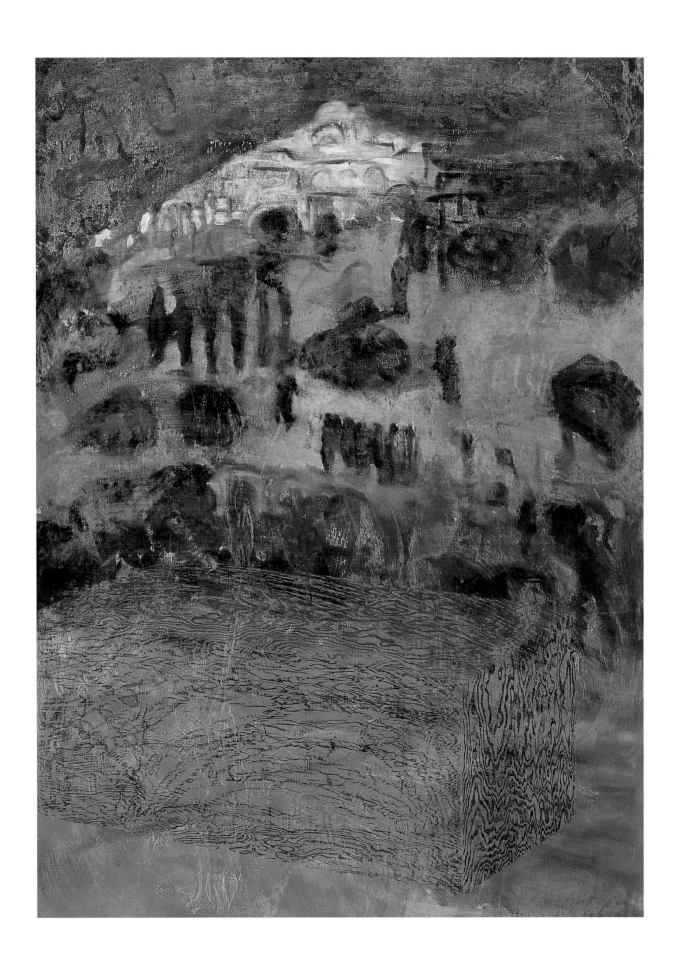

I shouldn't have been surprised, really, the last time I saw Di Stefano's studio in December 2000, and he unpacked a drawerful of works on paper from an ongoing series. They were black on white, in a few cases white on black. There were lines, mainly straight lines, of various frequencies and arrangements, done with brushes of all sorts of gauges, handled (of course!) with calligraphic expertise, and it was a sort of concordance or index of – it seemed to me – almost everything he had ever turned his hand to, but done with a radical, ideographic simplicity. A bunch of *études*. It was Arturo's alphabet, and I realized with a shock that what he'd done in these past fifteen years was so distinct and so coherent and so evolved that he had every right to it, and that I could even read some of it.

25
Arcadia
1989

Oil and wax on linen
208×151.7 [$81\frac{7}{8} \times 59\frac{3}{4}$]

case, the middle, the epicentre of paint; this bringing the depth to the surface is what you might say Di Stefano endeavours to do in all his work.

The painting is the body, the counterproof the sheet that osmotically, geologically, inexplicably, is marked by it. It is a divided likeness, the cumulative seeing I spoke of earlier broken haphazardly in two. The counterproof is a response, a critique, an abstract, an echo. It is like the steam of a dish, not the dish itself, it is a further emanation of a painting, a ghost, a surge, not the body of a painting, but its spirit. Everything – form, content, colour, line – is susceptible to alteration. Contrasts are weakened as more white comes on the scene. And yet it is precisely their revised materiality that is so moving about the counterproofs – exactly as in the case of the shroud, in fact. They are like the mortal frescoes that are discovered in Fellini's *Roma*.

There are sides of Di Stefano's work I haven't attended to at all. There are the portraits he made probably throughout his career, whether commissioned, or of family, friends and close associates. There are the efforts in the late 1990s to bring together such paintings of people with the painting of place, resulting in ambitious, frankly autobiographical – and therefore to me slightly uneasy – paintings such as *Penguin House* (pl. 50), the more convincing *Pier* (pl. 65) the following year, with its unusual low vantage of the Thames and the powerful gridding of supports and planking measuring and separating the five people, and also the beautifully atmospheric and (again) Felliniesque series of aquatints called Strands, beach scenes of enormous delicacy and fragility. Then there are the paintings of some of his studios – principally, I think, the doomed one in Mill Street – that constitute the bulk of his interiors (though there are also a number of paintings of staircases and corridors that strengthen one's impression of Di Stefano as in transit), and are among his very best work. Like his outdoor paintings of buildings and streets, there is something ambient or undirected about these; the angles are oblique, diagonal traversals of space, maximizing the incidental clutter and detail. The low ceilings contribute an echo of Beckmann's theatricality and claustrophobia. In some, as I've said, a window shines for all it's worth, like the exit of a mine or cave; in others, such as *Studio, Mill Street, SE1* (1996), there's an atmosphere of nights spent making ready for departure. Some of these studio paintings are brightly coloured: the *Studio III* (pl. 32) of 1991–92 that graces the cover of Di Stefano's Walker Gallery exhibition catalogue of 1993 in rusty tanker colours, orange and brown and heavily marked off-white concrete; others are sober, even monochrome.

The debate about colour, like the debate about abstraction, has accompanied Di Stefano throughout his career. There is a *Camera Lucida* (pl. 56) and a *Camera Obscura* (pl. 52). There are carefully painted palm trees that come out like explosions in counterproofs. There are *Arcades* in black and white and grey, and others that are picked out in yellow and purple. The crimson *Muleta* (pl. 53) and *Veronica* (pl. 54) retain their power to shock; the lightness and whiteness of *Waterloo*; a series of the *Tuileries Gardens* (pls. 26, 27) from 1991 and 1992, with rapturously scribbled flashes of colour.

privacy possible, hiding and seeking; it is even the jumping-off point for *Arcadia* (pl. 25), the title of Di Stefano's first landscape, painted in 1989. It can be in colour (the heightened red and blue of *Arcade, Paris,* painted in 1998), or the very effective monochrome – that, once again, traces its descent clearly back to the shroud – used for the moonlit chapel or a watery Venice in *St Paul de Mausole* and *San Marco, Venice (Acqua Alta)* (pl. 14). Wherever it is, though, we feel a solemn or joyful self-recognition on the part of the painter.

A kind of side-spur of Di Stefano's preoccupation with (preoccupied) locations and with the immanent presence of exalted spirits has been his unadvertised, hermetic and sporadic pursuit of Max Beckmann. Beckmann, a painter of mythology shading into autobiography, a wonderful model of industry and determination, a transient in Berlin, Frankfurt, Amsterdam, the South of France, St Louis and New York City, first turned up in Di Stefano's work when he was one of fifteen painters whose portraits made up a kind of second Sudaria in 1990 (perhaps symptomatic of Di Stefano that the writers and intellectuals took precedence over the painters!). In the portrait (pl. 15), Beckmann is his characteristic bullish and dominating self (familiar from so many of his formal and frontal self-portraits). His right foot slides down into the bottom-left corner of the picture, his bald head menaces its top edge. His left hand is in his pocket (the left arm bulks out the torso), his right holds a cigarette in front of his – at a guess – medicine-ball paunch. (His marvellous diaries are about nothing but eating, drinking, working, reading and conversation.) He could be an officer, a wrestler or an industrialist. His suit is a little big on him, sags, flows, almost melts, the bare boards (of his studio?), like ship's planks, come steeply down. His face is heavily lined, his puffy eyes are narrowed almost to the point of sightlessness, toughness and melancholia must fight it out, the horizontals of his right hand, his set mouth and his implacable glare are all that oppose the steep and darkening downward drift of the picture. Di Stefano made his painting from a 1938 photograph; Beckmann is already a 'degenerate artist', he will not see, or certainly not live in, Germany again, he is facing another seven years in Amsterdam – on an uncertain footing with the German occupying forces, and then with Allied bombing raids to follow – and five more in the United States.

Di Stefano literally 'doorsteps' him in *85 Rokin, Amsterdam* (pl. 58), seeks him out in the Stedelijk Museum in two more hauntingly anonymous pictures, and then afield to Scheveningen (*Road, Scheveningen, The Beach at Scheveningen* and *Beach*), where, if memory serves, Beckmann and his wife went cycling as the War was coming to an end, to palmy Nice (*Nice* [pl. 59] and *Mirage* [pl. 60]) where he revisited – he too – old haunts after the War, follows him to the Tuileries and Central Park, where, in 1950, Beckmann suffered a heart attack and died while walking his dog. Beckmann is a sort of invisible thread for the pearls of the pictures. The informal series is the shyest, most sidelong of homages.

One can see Di Stefano's paintings as revisions, as second sight or hindsight. With a kind of fanatical humility and loyalty, he will tend to restrict himself to

things oft' seen – by himself or by others. He seems to believe in seeing as something cumulative, something that engraves itself into its – often inconspicuous, *unscheinbar* – object over time, perhaps like the vision of those believers who saw Christ in the shroud and the cloth. It is a transitive type of seeing, capable of rescuing – of making relics or icons of – such distressingly nondescript things as the front door of Beckmann's apartment, as the mysterious underpass on Crucifix Lane, as the many oblique views of "places of art", as Nicholas Alfrey has called them, that you find in Di Stefano.

What enacts or enforces this 'transitiveness' is at the same time Di Stefano's most alarming and characteristic act as a painter: his way – it's not a technique, partly because it encompasses a variety of techniques, partly because of its inherent unpredictability and uncontrollability, partly because it seems deeper than a technique, more like its own mode of expression – his way, then, of taking a 'finished' canvas or other piece of work, and variously treating or disfiguring or otherwise interfering with it. Obviously, this can be traced to the influence of the Turin Shroud: the appreciation that the power of an image is in no way dependent on its technical virtue, or its preservation; perhaps even the opposite, that it is in inverse proportion to it. If the effect of time, impairment, neglect, the tramp, as it were, of thousands of pairs of eyes, can be created or suggested or mimicked, then that will have the effect only of fortifying the image. In some of his writing about Berlin – the large, blank, scabby 'firewalls' at the sides of buildings or rows of buildings that are such a feature of Berlin – I recall Wim Wenders advancing the idea that the eye, the camera, the memory is always more apt to cling to these roughened surfaces than to something slippery-smooth, sheer and unmarked. (Think, here, of Di Stefano's painting *Mending Wall* [pl. 69].) Something fleeting, rushed, *en passant*, affects us more than something lengthily established, prepared and considered. Music from a passing car radio, a tinny music box, the accordions of Laforgue or Rilke's violin "as you walked/ under an open window": anything like that is better than concert conditions.

I don't suppose for a moment that there was any rational calculation of *effect* that moved Di Stefano, merely the understanding of the power of an ambiguous texture, a scumbled surface, a blurred signal. In his Sudaria sequence, the heads of the writers occupy only part of the squarish format, and are then harshly overpainted and tenderly corroded. Looking at them, you do indeed get a sense of heat, and of melting. Later on, images are projected or printed on to other images. Following a studio fire in 1987, in which almost all of Di Stefano's existing work was destroyed, he went at the ideas of cloth and damage with a new grimness of purpose, in a series of paintings given the inevitably punning title of Pall – a funereal covering and a shroud of smoke. These only gradually regained an appetite for form and likeness, and when they did, it was combined with an unwonted savagery: in *Pall: Ixion* (pl. 5), a broken, sexual figure opposing its pallor to a streaming blackness from the top right, as harsh as a woodcut (I am put in mind of Nolde's suffering *Prophet*), and with

a shocking spurt of red wax seared into it; or *Carphology: Danaë*, the opposite story – mortal woman impregnated by Zeus, as opposed to king falling for Hera, and therefore not entailing fearful consequences – Danaë more sedate, looking up from a coiled, seated position, under a luscious, scribbled cloud of gold.

Wax for a time remained Di Stefano's preferred secondary or disruptive medium, either melted or scribbled or pressed. It seems to represent time or consequence, to have something admonitory or already punitive about it, a weathering, a lining, a lichening. Sweeping or febrile marks, parodying the texture of draughtsmanship, blur the inessentials and seem to give greater emphasis to the figures, in his 1990 series of painters, for example. It makes each image unique, in the way that a postage stamp is individually cancelled by its postmark. It removed them from their photographic sources by stressing their vulnerability and contingency. The only thing wrong with wax was its relative amenability to the artist's controlling hand and eye. Di Stefano wanted a second process that would have a more powerful, more unpredictable impact on his painting, and over the next few years he evolved just such a process.

Initially, as I understand it, he overpainted his paintings, applied varnish to the wet paint, and then used newsprint to sop up and wipe away the loosened, uncertain surface. The resulting effect was a blurring and mingling; it may be seen in paintings such as *Royal College Street, NW1* and *Hotel Splendide* (pl. 41), both begun in 1994. The overall painting was 'brought in touch with itself', as it were, its colours very briefly and brutally put in a blender. The ox blood of the upper floors of *Royal College Street, NW1* bleeds on to the sky and the white *rez-de-chaussée*; something of the sky's skimmed blueish pallor besets the building; there's a commotion of murderous colour in the windows; while, in *Hotel Splendide*, the *faux*, bricked-in windows and arches seem to move wittily to the side, something of the street's asphalt lifts on to the grubby stucco, the light is dramatically unstable (the right side is like one of Beckmann's night-and-limelight paintings), the whole thing has the rhythm and taint of occupation. Both buildings have put on a quality of *representativeness*: it is as though they had been exposed for a very long time to a lens, and this is their median condition. The painting seems commensurate with architecture; its means are compatible with it, if not actually identical. Qualities such as 'old' and 'new' seem to have been neutered, and a more durable and companionable reality has been captured. It is not a momentary or anachronistic vision, but a sort of composite. Buildings and pictures are coevals.

There seems to me to be something exilic about this procedure: the randomness and intentness, the de-layering eye, the apparent invisibility of the speaker or observer, the constatation that life is short but art – or a city – is long. These buildings – not immediately, but cumulatively haunting – are what come to obsess him, they are where he wears out his hands and feet, his eyes and his imagination, and something of all that becomes apparent in his view of them. They would be an ideal match for an exile's writing, say Vallejo's in Paris, or

Jean Rhys's in London, or Joseph Brodsky's in Italy: "The doors take in air, exhale steam; you, however, won't/ be back to the shallowed Arno ..." ('December in Florence'). Even in Brodsky's own account, the buildings have more life, more expectancy of life, and more animation than – with all sobriety and lack of self-pity – the exile himself does. It is a characteristic of Brodsky that I keep seeing in Di Stefano also that, centrifugally, as I remarked earlier, his surroundings have a life and an orientation that he himself does not; neither proposes himself as a centre; rather, they would leave it to us to identify them from wherever they have been. Not even in his Nobel Prize acceptance speech in 1987 – when surely it would have been expected of him – did Brodsky muster any sort of self-importance, only a kind of Baltic by-play: "Nonetheless, it pleases me to think, ladies and gentlemen, that we used to inhale the same air, eat the same fish, get soaked by the same – at times – radioactive rain, swim in the same sea, get bored by the same kind of conifers." Instead, he prefers to think of himself as, in some sense, statistically, or relatively, or *sub specie aeternitatis*, not really there at all: "And as far as this room is concerned, I think it was empty just a couple of hours ago, and it will be empty again a couple of hours hence." It is precisely this feeling that is communicated by the paintings of Arturo Di Stefano. It is what the German poet Peter Huchel wrote: "*Gedenke meiner, flüstert der Staub*": "Remember me, whispers the dust."

There is one further development even from this roughing up and abrading and stripping of a painting, and it didn't take Di Stefano much longer to arrive at it: it was to overpaint and varnish his painting, as before, but then, instead of newsprint, to press and rub it on to fine, heavy, durable paper, and to keep the resulting *impressum* – a unique conflation of oil painting and print – as a counterproof. Once again, as with the puns and sequences, unfolding underwrites uniqueness and authenticity. (Some of them have beautifully witty titles too: *Pall: Charcoal* [1997] throws off a *Carbon*; some inverted palm trees are called *Mirage*.) The whole process, obviously, has vast and curious implications, and the results are quite thrilling to behold. I don't think I can improve on my own first impressions, written down in the catalogue for Di Stefano's 1998 show, *Strands*. "It is," I wrote:

to reinstate chance after the exercise of his own skill as draughtsman and painter. To unmake, having made – like Penelope at her loom. To split colours, as, curiously, the paintings and counterproofs have completely different sets of tonalities from one another, as well as movements and rhythms. To peel off a bandage from a fresh wound. To lend an impression of speed to something static – for instance, in the wonderfully brooding Crucifix Lane, SE1. To strengthen the sense of absence by the 'wiped' effect – we seem to be seeing the dying echo of a human aura, to be witnessing the immediate aftermath of something. To give the painting almost a non-visual dimension, in the way that in an imperfect electrical circuit, some of the power goes on heat and noise; look at Crucifix Lane, SE1 for long enough, and it will rustle at you like the soundtrack of an Antonioni shot. To show not the surface, but in each

(Perhaps it is his equivalent of Dr Johnson's high road to London for the benighted Scotsman.) The obverse of *Waterloo* might be the painting *Demolition Site, Mill Street, SE1* (pl. 68), made the following year: a seemingly dispassionate – an engineer's – investigation of a different set of machinery, that of destruction this time, not departure, but the same oddly blithe clarity lying over everything, and the little banner-like flecks of red and blue still being flown from within these broken-open cells that were once rooms. Or, actually, studios. What the painting is celebrating – it doesn't seem the wrong word to use – is the demolition of Di Stefano's workplace. The approach couldn't be more different than that taken by Rilke in his Paris novel *The Notebooks of Malte Laurids Brigge*, where the sight of wallpaper, fireplace, pipes, all suddenly laid bare where a house has been pulled down, fills Malte with a nauseated foreboding, a bitterly existential protest at things being thus turned inside out. But perhaps the conclusion is the same: "the stubborn life of these rooms had not let itself be trampled out," and the lesson for the artist: "That it's not impossible to see everything differently and still remain alive."

The earliest of Di Stefano's architectural paintings date from 1990 and 1991; they are *St Paul de Mausole* (pl. 13); *Via Roma, Turin* (pl. 12); *Place des Vosges, Paris* (pl. 30). What they have in common are, *prima facie,* their arcades. Even this – along with the cloths, probably Di Stefano's most distinctive motif – owes something to that shroud, *via* a painting called *The Shroud of Penelope (Rove)* (pl. 8) of 1988. On that occasion the cloth, here borrowing overtones of Penelope's weaving, is combined with the arrow – the sign of the returning Odysseus, the marksman, who first fires an arrow through the rings of twelve axeheads, to prove that it is he, and then sets about the suitors. The combination is validated or authenticated by the pun on 'rove': a term from archery (a randomly chosen mark, as opposed to a fixed butt); then a term meaning to tease out and twist a fabric such as cotton or wool (adjacent, maybe to 'carphology'); and, most obviously, to err, to wander. Thus it combines in itself the activities, even the story, of Odysseus and Penelope. Di Stefano is an adept at this kind of 'logomancy'; the paintings can seem like accounts or maps of his own logodaedalist wanderings; they follow where the mind has been. Arcade, then, from *arc*, a bow; and then rapidly spreading through Di Stefano's iconography *via* Turin (and the Via Roma); and *via* Walter Benjamin, one of his 'saints', who was engaged for many years upon a work he called *Passagenarbeit*, in English, *Arcades*. (Passages that have something about them too of mine-galleries.)

It is hard to sum up all that the arcade might mean to the painter: a place of communing with spirits like Benjamin's (in Paris), Van Gogh's (in Saint-Rémy), Pavese's and Primo Levi's (in Turin); a place that is both covered and open to the elements, that is both frontal and lateral; tradition and the individual talent; a kind of main cave, with side antra, and thus a suitable representation both of memory, and of the layout of Di Stefano's confined and ramifying œuvre; a graduated space that measures itself; a subject that tests light, shadow, perspective to the limit; an ancient, holy form of church and cloisters, now given over to commerce; an arrangement that makes both vision and

Di Stefano responding to *Crucifix Lane, SE1* (pl. 38), to *Royal College Street, NW1* (he did after all attend a 'royal college'), or *Orange Street, WC2* (which has "St. Martin's Street", the name of a rival establishment, easily legible; pl. 40).

The paintings then, are private takes on public places – or even, and I think more accurately, private meanings sandwiched between the public space and the public-seeming painting. Di Stefano is, as it were, between a rock and a hard place. Hence, perhaps, the courage that the pictures seemed to call for from the artist; I have always thought of these, in a way I couldn't explain, as *brave* paintings. There is a sense of something soft and undeclared striving to persist between the public façades and the surface of the public-seeming paintings. For these are not public paintings – analogous, if you like, to public poems. The subjects are chosen for the most tenuous, perhaps the most intimate, but the most binding reasons, to do with the name, to do with art – *Orange Street, WC2* shuffling past the National Gallery into what looks like a dead end, *William Brown Street, Liverpool* looking quite as likely to bounce off its obliquely struck façade as actually to go inside the Walker Art Gallery, *South Bank* (pl. 39) facing away across the river, the halls, the staircases, the corridors – to do with autobiography or biography. An instrument of quivering sensitivity has come up to these (often) grand cultural sites, these monuments and places of pilgrimage by the coach-load, to see what it registers. Is there anything numinous?

The first thing one notices is that no one else is looking. Whether or not someone has to do it, it is certainly lonely work. For once, the Germans haven't got there first, as they have, say, with Caspar David Friedrich, who is made to look around heads and over shoulders. This takes one, perhaps, to the next point: (unlike Friedrich) these aren't exalted or sublime. Even if some of the buildings in them are beautiful and famous, and some of the views, the results are not often 'picturesque'. Di Stefano is too attentive to the humble detail of street furniture, bollards, lampposts, signposts, street signs, plaques, railings, benches and bins, single and double lines, and so on and so forth. Furthermore, the places he is drawn to, and draws us to, often seem to be stylistically inharmonious (*Crucifix Lane, SE1*) or in a bad state of repair (*Royal College Street, NW1*). The blitheness and gaudiness of the postmodern frequently make themselves felt: the eccentric battleship in *Pool of London* (pl. 63) moored in front of the converted warehouses, the red buses and the blue-glass towers on the right, the whole ensemble parked under a hesitant peacetime sky. An entire rainbow has gone into the making of *Coram's Fields*. One really can't look at Di Stefano long without being struck by the motleyness of how and where we live: the eerily light modern materials and primary colours in places, how patched and thrown together everything is.

I don't think Di Stefano is saying, with Chekhov, "how badly we live, my friends", but I think there's a comic disappointment; someone who might have been a severe stylist, and who certainly has a streak of severity, even of Puritanism or of Zen in him, is discomfited by the kind of crazy lightness that was applied to things in the last decade or two. *Waterloo* (pl. 45), in particular, looks like a toy, painted in silver and gold with red and blue, and an exuberantly pedantic proliferation of structures that the unwontedly light-hearted painter can just lose himself in.

case, the biographical connection, Di Stefano, it seems to me, is trying to force what otherwise would have been merely circumstantial underground, so that it leaches through in the form of 'presence', raptness, atmosphere. Certainly, our being forearmed or already privileged possessors of some particular knowledge is not his plan or his way. Rather, the painting should speak for itself, and a snippet of fact – when it comes, when it has got itself circulated among the admirers of his work – should be merely corroborative. Rimbaud and Verlaine do not 'make sense of' *Royal College Street, NW1*, but it makes sense that a painting in such colours, with such menace and cold, should be associated with an episode such as theirs.

There is about such a procedure shyness, reticence, a deep modesty. If there is something tangential, fleeting, almost furtive about Di Stefano, creating his works within the shafts and tunnels of his preoccupations, we ought to remember that it would have been possible for the work to have had a completely different air: declarative, overbearing, buttonholing, touristic, ostentatious, all the strings securely in the grasp of the painter, and all leading us by the shortest route to his psychobiographical predicament. The horror one feels at such a prospect shows how far it is from being the case! Instead, the painter abdicates control, allows things to be centrifugal, insists on himself less than one would have thought possible, forces his admirers to pool their knowledge, to – literally – scrape him off various walls. I am reminded of Rilke's – admittedly rather *larmoyant* – poem 'Der Dichter', 'The Poet', which ends: "*Alle Dinge, an die ich mich gebe,/ werden reich und geben mich aus.*" "All the things to which I give myself/ grow rich and spend me."

Di Stefano's paintings are rich, and mostly he is not obviously anywhere in them. Sometimes a place name summons him like an imperative, and he duly presents himself; *Sicilian Avenue, London* (pl. 33) has an obvious appeal to this English-born child of Italian immigrant parents. A mild, soiled grey and pink conducts to a possibly spring-like green at the back; the view is clipped above and below by the architrave and the pavement's edge, cheerfully on their way to infinity to meet; the Ionic pillars are not unlike bars; the shopfronts on the left seem to grind space like a milled edge. It is not as sinister a painting as, say, *Royal College Street, NW1*, but there is a puzzlement, a perplexity at seeing this trapped, caged, almost boxed space.

Sicilian Avenue, London, is, as it were, 'his' space, but Di Stefano also delights in seeking out – or, better, in answering the summons of – spaces that are not his, that are already variously spoken for: *William Brown Street, Liverpool* (pl. 37); *Place des Vosges, Paris* (pl. 30); *Via Roma, Turin* (pl. 12); *Coram's Fields* (pl. 64), where he intrudes or spectates. The proper names, and the hint of misdirection, are, I would guess, an important part of Di Stefano's interest in the places. There is something exilic about them – who else, after all, so uses public space, tramps the streets, haunts the parks and gardens, stares at the pitiless façades of buildings, as the exile, *flâneur malgré lui*, be he Benjamin or Brodsky or Baudelaire? The hapless, literal-minded following – or disobeying – of instructions or labellings is a part of this; the street name reads like an imperative. Just as to *Sicilian Avenue, London*, one can feel

'working-through' this or that subject, hence, too, the inability or unwillingness to explain or present a theme or range of themes – because that would imply he had successfully extricated himself from whatever it was. As in the case of the miner, the material is all around him, and he hacks at it until it is gone. Hence the many views of studios, doors, windows. And the names of them, discreet, troubling, allusive or ambiguous: *Net, Cast, Loom, Limen, Blind Jealousy.*

Many of Arturo Di Stefano's works take up an area between Man and Nature. There are trees, but they have been put there, in parks and verges. There are swimming pools and zoos. There are human likenesses, but they have been degraded and processed to the point that they might almost be part of nature: *Revenant 1* (1989–90), enmeshed or enthorned like Sleeping Beauty; *Bather* (pl. 23), projected on a rippling wood-pattern; *Mnemosyne* (pl. 11), a flashback on a daubed grain. There are people posed in front of scenes, but many of them so uneasily that the result is a stand-off. There are roads without cars, railway lines and the fascinating neural tangle of overhead wires without trains, streets without people.

What we are seeing is the unsettlingness of settlement. Paintings of buildings – *Royal College Street, NW1* (pl. 42), where Verlaine and Rimbaud roomed together – in which the painting and the building are co-substantial, flesh of one flesh, and that flayed as Marsyas. And yet, as in the case of the Turin Shroud, as in the case of the Veil of St Veronica, there is something *evidential* about the paintings: Di Stefano's walls talk. The first catalogue of his that I have, from 1991, with a text by Yehuda Safran, has an epigraph from Ingres: "... even the smoke must be expressed by line." Smoke, of course, being classically evidential, civilizatory, Promethean or propitiatory – later to become the punning colloquial title of a 1997 sequence of drypoints and aquatints of London: The Smoke. The last time I was in Di Stefano's studio, he was working on a life-size, or possibly larger than life-size, painting of a brick wall that had spoken to him: a *tache* of sky, and then row upon row of bricks and mortar, the act of painting almost like bricklaying – I expected him to be using a taut string, to tap the set bricks with the heel of his brush. It was, I have to say, a speaking likeness.

Typically, associations are not declared – sometimes they are not even hinted at – by Di Stefano. The paintings and the subjects make themselves autonomous, and proclaim their independence. It will not say, I suspect, that the brick wall was round the corner from his studio, in Bow. Perhaps it doesn't matter. It doesn't say that Verlaine and Rimbaud lived in the building in Royal College Street – perhaps the painting doesn't want to be anecdotal, doesn't want to wear its drama on its sleeve. But if we know it, the unbalanced house, the mad house – with its walls the colour of dried gore, its drained, ghastly (*blême*!) sky, its lace curtains seeming, macabrely, to sheet its windows, its sinisterly long doorways, its basically *tricouleur* palette of red, white and blue, flat and drunk and looming like some of the buildings of Munch or Schmidt-Rottluff – can only grow on us. By suppressing, in this

theatrical versions: now as the shirts of Nessus, of Deianeira, of Hercules; now as the muleta and veronica of bullfighting; now in the guise of palls and cerecloths and shrouds; as the *Merciful Curtain* and the Carphology pieces ('carphology' being the word for 'the movement of delirious patients', plucking at bedclothes and the like – a wry self-description for what the painter does). Fifthly, one might adduce a more general quality of mystery that is rarely absent from Di Stefano's pictures. All these things are more or less there, from 1986.

In this way, Di Stefano seems almost to be working underground – as his father did when he first came to England from Italy after the War. The work exists in seams, in galleries (no pun intended) and corridors, it is easy of access or arduous, rich or almost mined out. One might think of Di Stefano as working 'on the face of London' or on mythological deposits, along empty arcades or on shafts of portraiture. One has only to look at *Adit (Camera Obscura)* (pl. 52) or *Limen* (pl. 62). It is painting that does not throw up works in isolation, but that is everywhere secretly in communication with itself. The studio has a low ceiling, and the light is blinding.

Most characteristically, this painter is surrounded by his work. Not as Munch was, who left his canvases at the mercy of the wind and the rain, and didn't mind them getting a few holes, or Rodin, who so impressed Rilke by his industry and discipline, a Midas of marble and bronze, but again, more like a writer – like Kafka, in his long story 'The Burrow', or Lowell, who, in 'Reading Myself', compared his agglomeration of sonnets to a honeycomb, "adding a circle to circle, cell to cell", finishing: "this open book ... my open coffin". In general, one thinks of the painter as standing *devant le motif*, but the writer, or rather, these particular writers and Di Stefano, is engaged in a paradoxical mixture of tunnelling his way out into the open and, at the same time, immuring himself more and more irretrievably. The tools with which they are working to gain access to their liberty – words, paint, colour, line – are made of the same substance that, in Lowell's word, 'coffins' them. They are doubly used.

Hence, in Di Stefano, the puns, the *doublures – Strands, Bow Painter, Arcades* – hence the method of the counterproofs, the stress on the distressed or doubly distressed surfaces, the sense, almost everywhere in his work, that he is *unterwegs* or in transit (there is even a 1992 picture of that name; pl. 35). Hence the desolation and to me the unspecified phobic quality – claustrophobia? agoraphobia? – of many of his scenes, the obscure views, the decentred, almost *en passant* framing, the sense that the picture may have (just) come to a stop, but the building is still moving, a paradoxical nostalgia ('homesickness') for the vanishing point that arrows down his arcades and perspectives, or rounds the obtuse-angled corners in so many of his pictures. Hence the concentration of atmosphere – as in 'the plot thickened' – in them, the air of secret purpose or selection, a feeling at once of mission and mystery – not a riddle, because we haven't even been set the terms of a riddle; more like a crossword without clues. Hence the series, the

Michael Hofmann

Di Stefano's Alphabet

We can always pull in or roll out our beginnings, like a rope ladder of a certain length, but there is a case for saying that Arturo Di Stefano's self-invention or self-discovery as a painter dates from 1986. That was the year when, already thirty, and with a period of what one of his own later catalogues pitilessly calls "living in complete obscurity" behind him (since finishing at the Royal College of Art, London, in 1981), he found himself in Turin on an eight-month scholarship from the Italian government. The Turin Shroud had gone on show there at the cathedral, drawing huge crowds, and from it and from the Sudarium – the cloth with which St Veronica wiped the face of Christ on the way to Calvary, and which retained, purportedly, an impression of his face, as the shroud had of the body – Di Stefano moved on to make a series of twenty portraits of writers: a kind of personal 'pantheon' of, I suppose, modern masters: Kafka, Primo Levi, Walter Benjamin, Auden, Lowell, Baudelaire. There are great parts of Di Stefano's work that seem to have little or nothing to do with this sequence – the wonderful paintings of London buildings, say, or of littorals or pools – but there is a lot to which it does serve as a sort of key or introduction.

That a chosen face, the image of the face and the physical piece of cloth bearing the image should all be looked at with as much veneration and belief – or maybe suspicion – as that shroud: that seems to be a fair opening postulate to be derived from the Sudaria sequence. Then, there is a deep literariness – one would have to be Rossetti or Blake to be a more literary, or maybe I mean a more writerly painter – in Di Stefano: in the choice of subjects and the breadth and depth of reading that they entail; in the inveterate and profound wordplay of so many of his titles; in the way impalpable things such as time or narrative or memory seem to be woven into his pictures. Thirdly, there is an emphasis on the unconventional, the radical way in which the image is produced: by nature, by pressure, by inevitability; adventitiously, organically, uncontrollably; by abrasion, by interference, by subtraction. Fourthly, there is the interest in cloth and types of drapery; over many years the studious depictions of black and crimson and white, in recurring, almost

The Waters of Leman
(*detail*)
1990

Colour woodcut
Image size 182.9 × 121.9
[72 × 48]

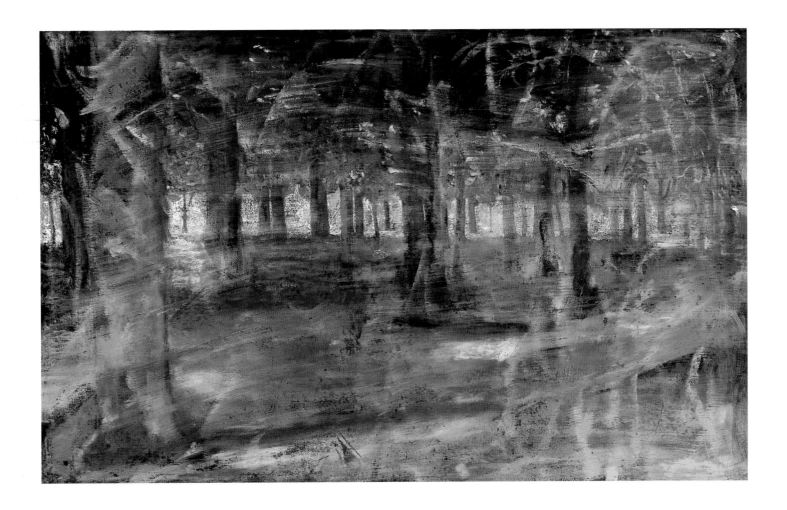

27
Tuileries Gardens, Paris III
1991–92

Oil on linen
152.4 × 243.8 [60 × 96]

28
Studio II
1991

Oil on linen
144.1 × 197.5 [56¾ × 77¾]

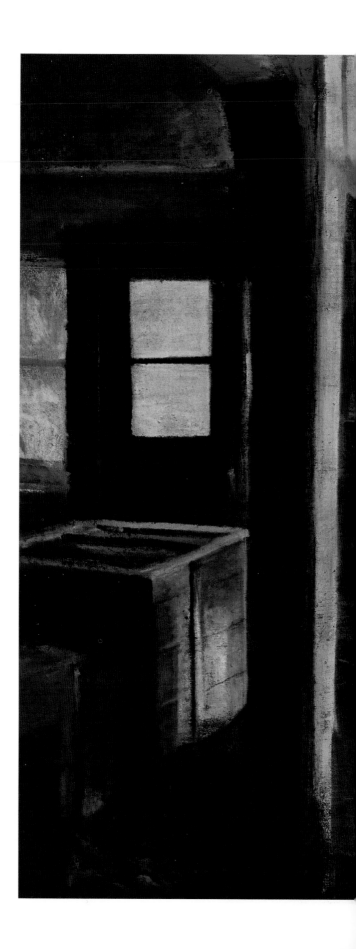

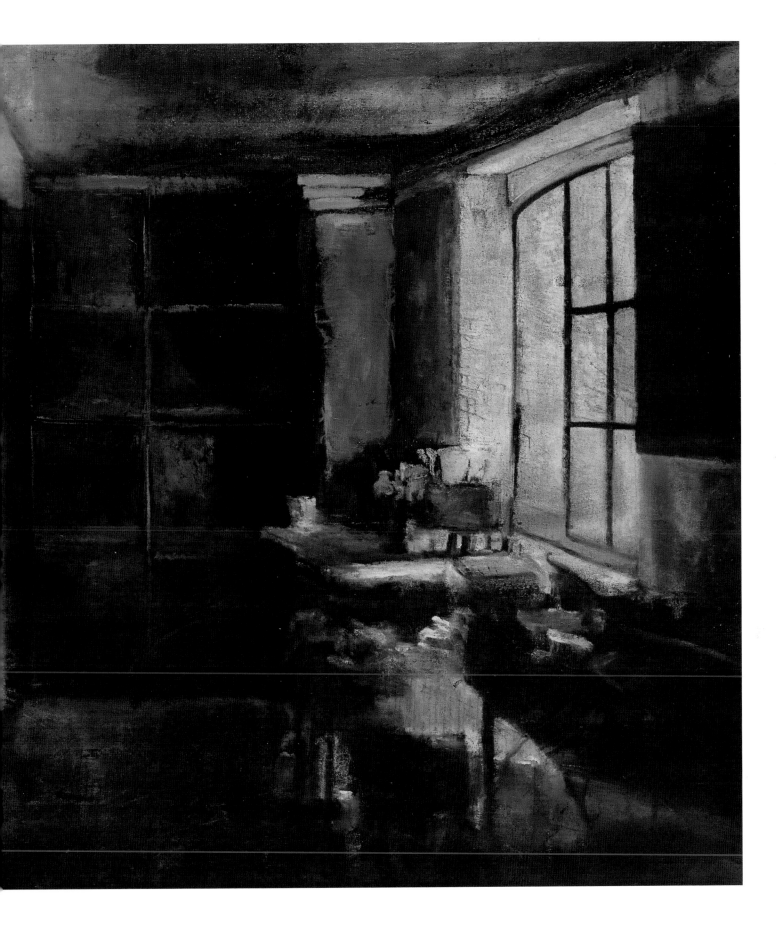

29
Contre-Jour, Barcelona
1991

Oil and wax on linen
205.7 × 175.2 [81 × 69]

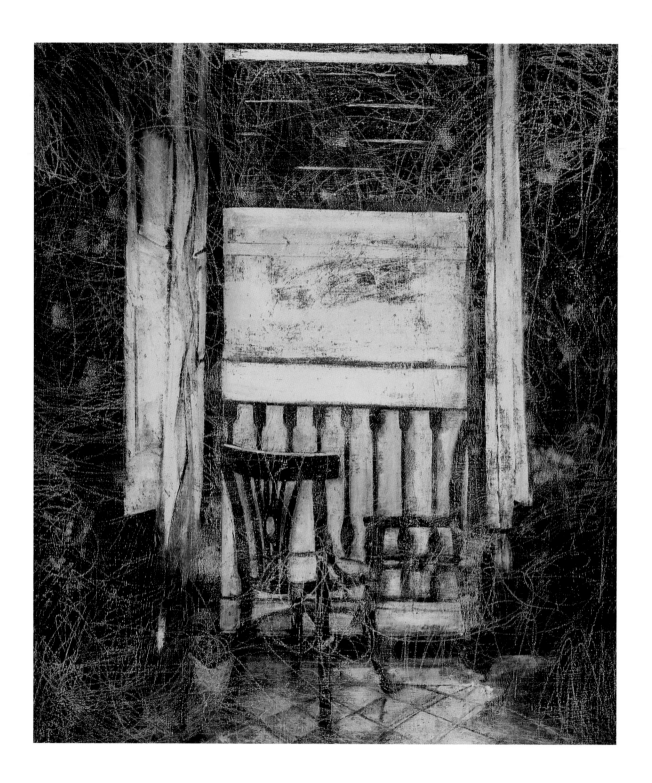

30
Place des Vosges, Paris
1991

Oil on linen
203.8 × 161.3 [80¼ × 63½]

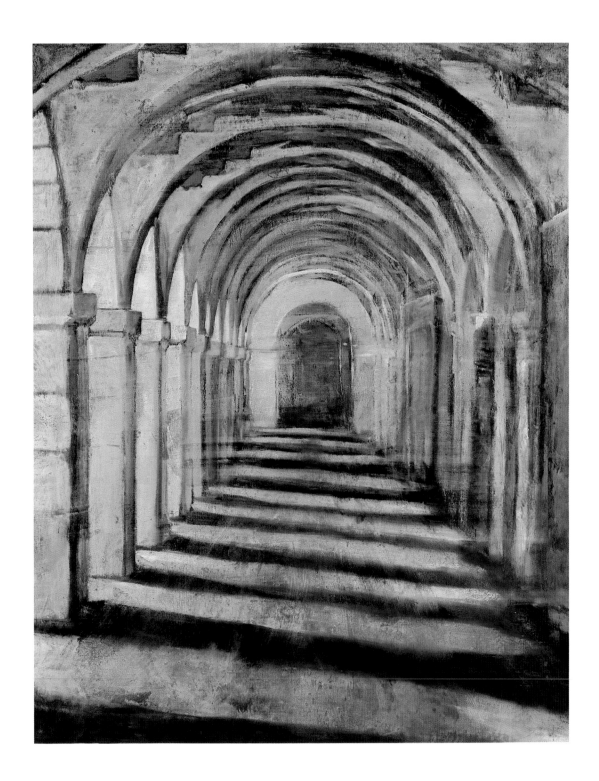

31
Studio V
1992

Oil on linen
152.4 × 243.8 [60 × 96]

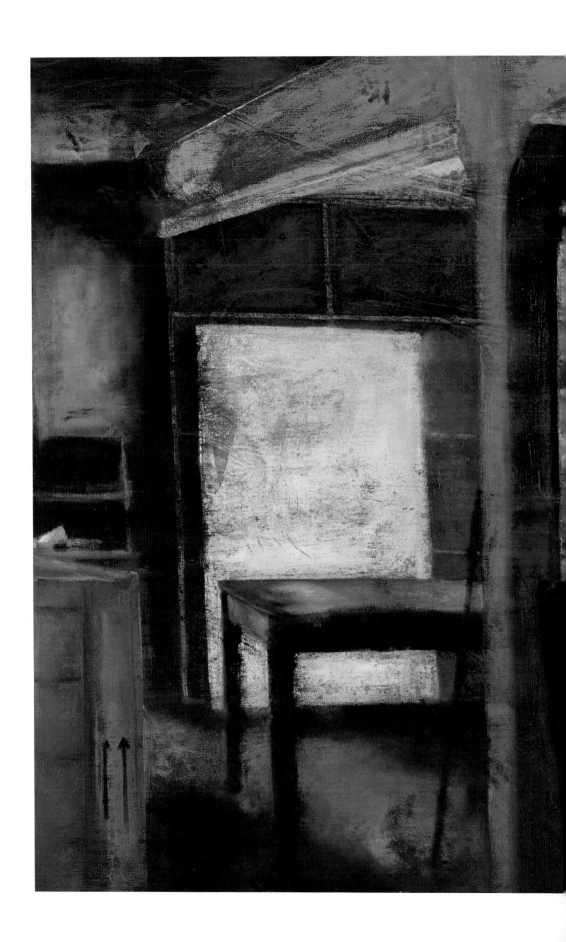

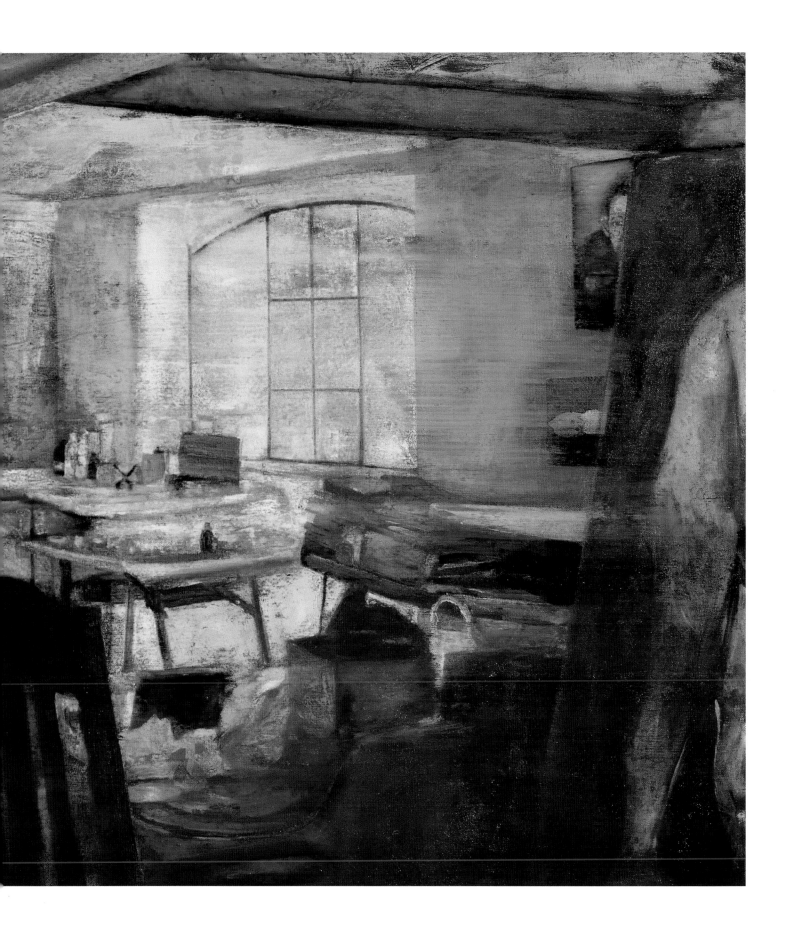

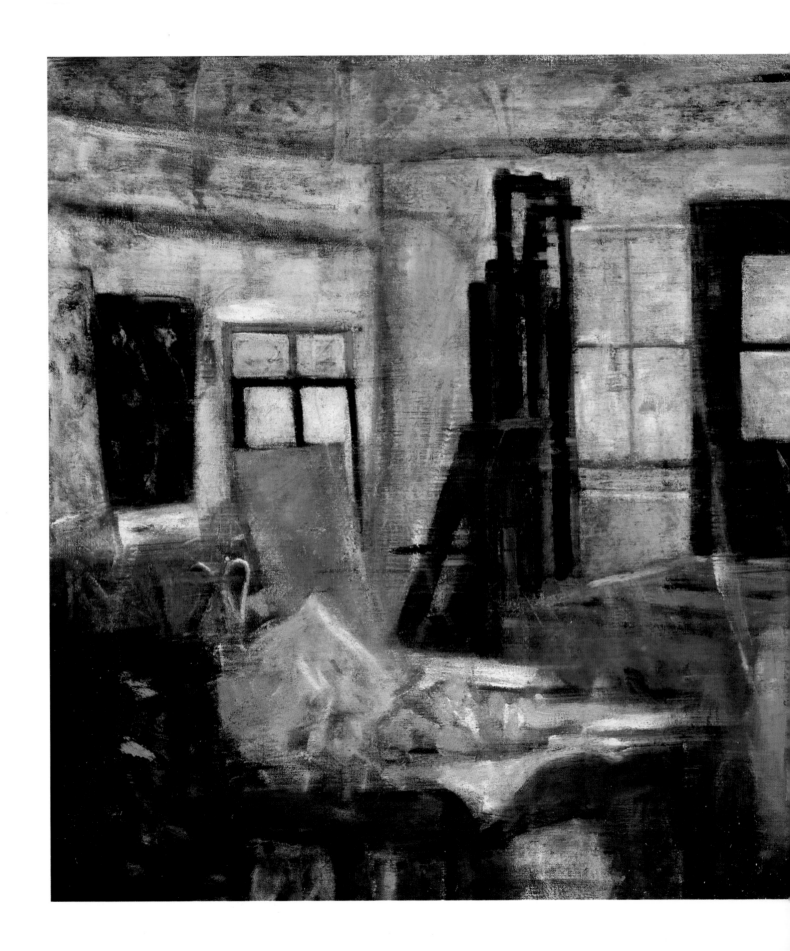

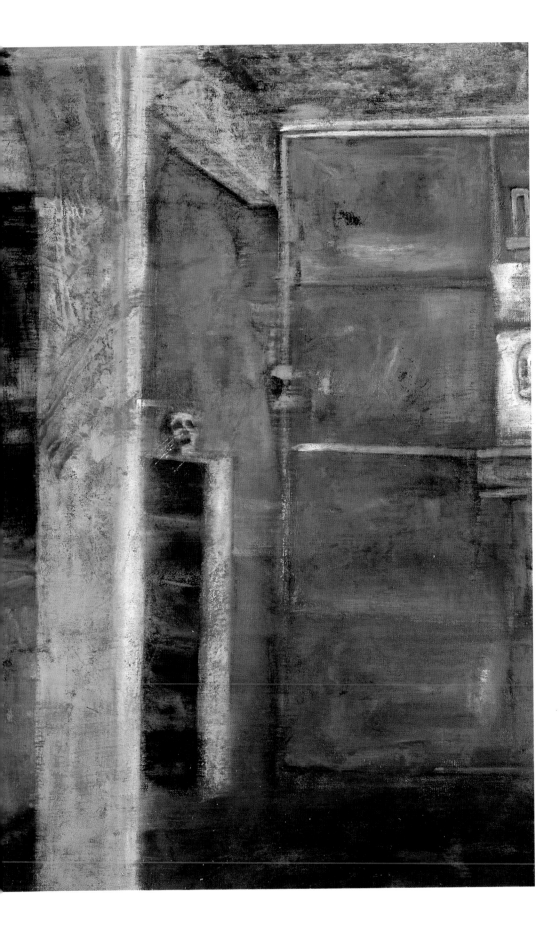

32
Studio III
1991–92

Oil on linen
152.4 × 243.8 [60 × 96]

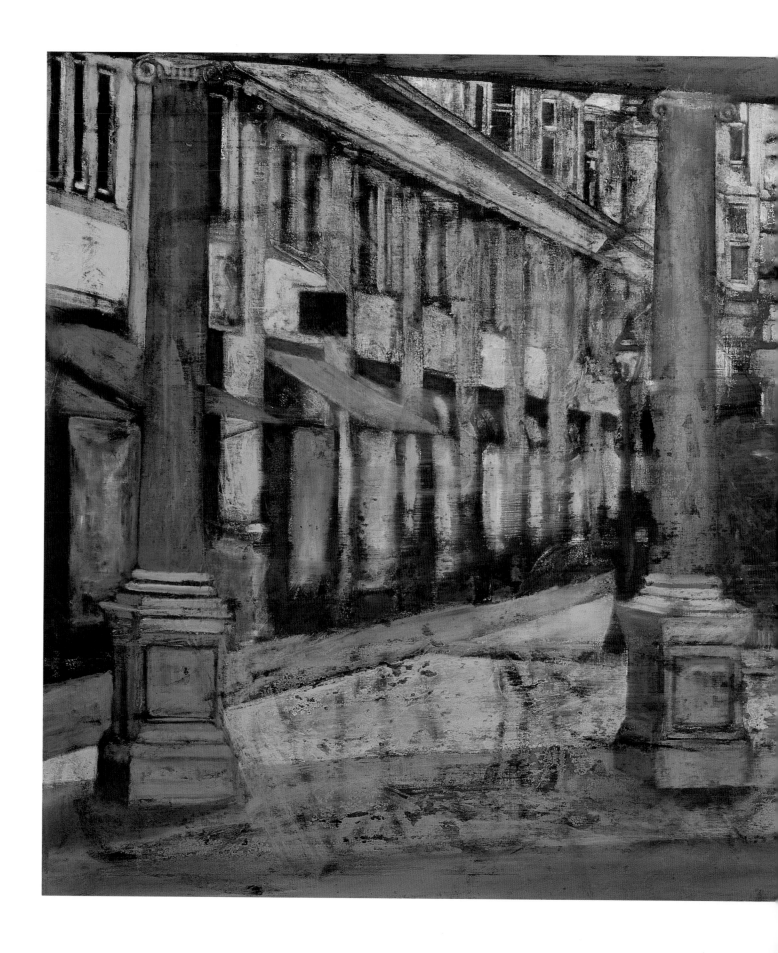

33
Sicilian Avenue, London
1992

Oil on linen
165.1 × 207.6 [65 × 81¾]

34
Montelimar I
1992

Oil on linen
189.8 × 144.1 [74¾ × 56¾]

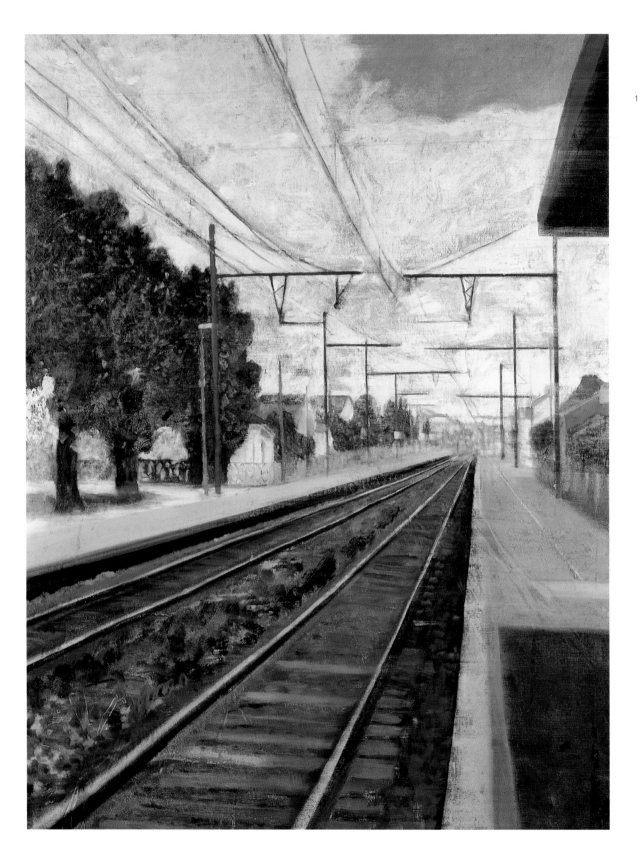

35
In Transit
1992

Oil on linen
187.9 × 132 [74 × 52]

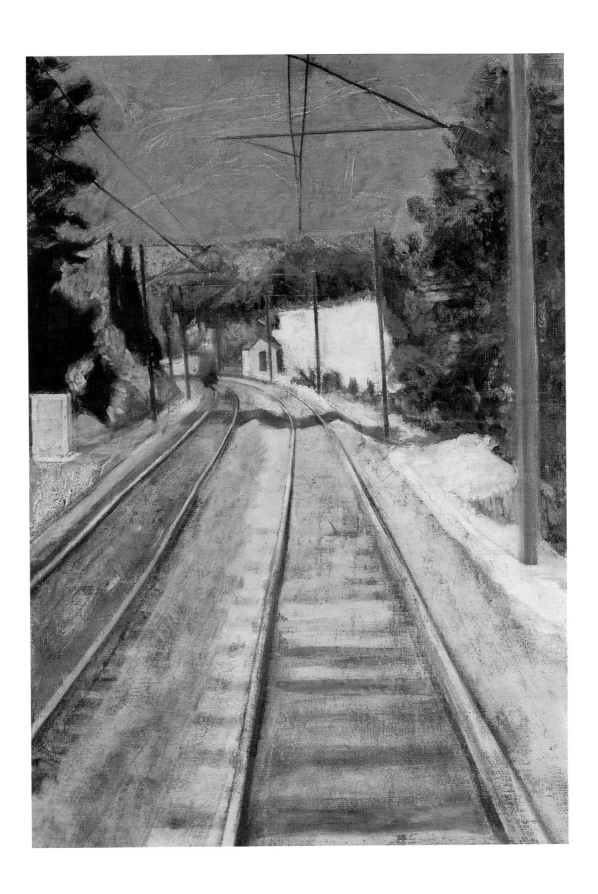

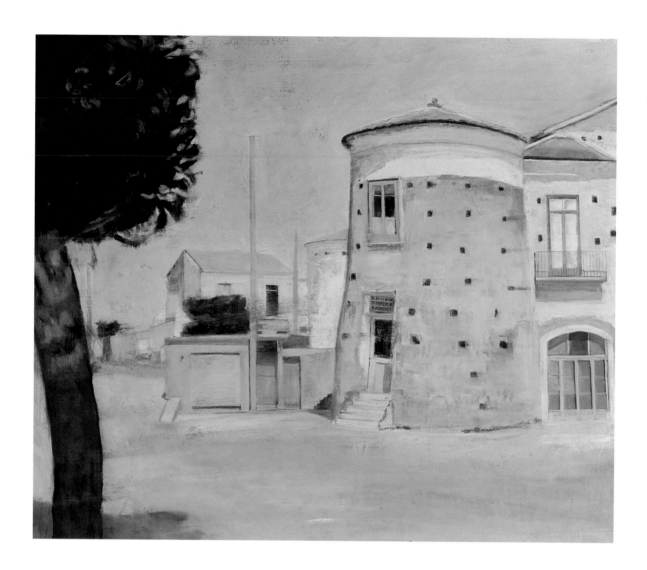

36
Bonito
1994

Oil on linen
167 × 197.8 [65¾ × 77⅞]

37
William Brown Street,
Liverpool
1994

Oil on linen
167 × 197.8 [65¼ × 77⅞]

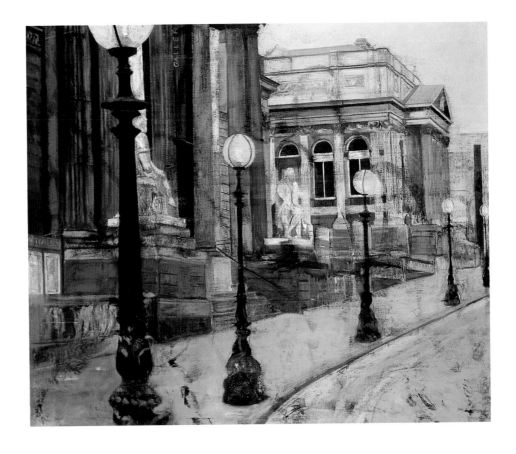

38
Crucifix Lane, SE1
1996

Oil on linen
148.6 × 200 [58½ × 78¾]

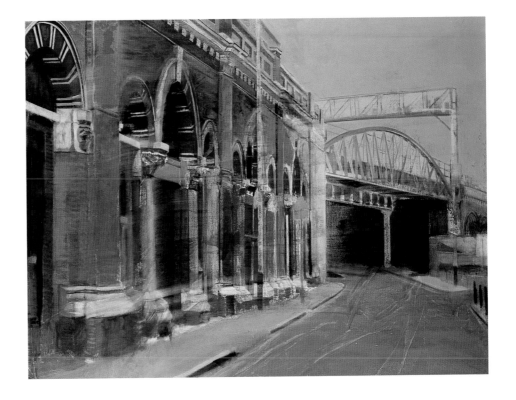

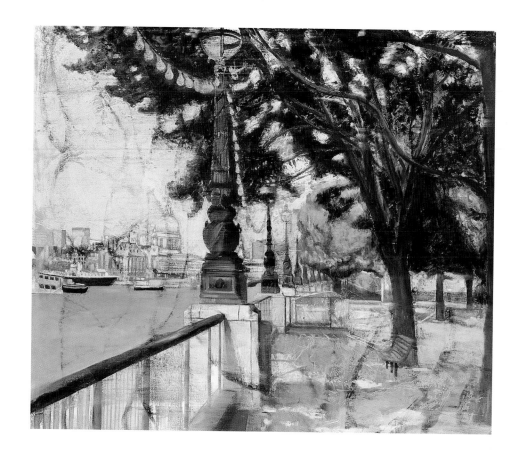

39
South Bank
1994

Oil on linen
181.6 × 212.7 [71½ × 83¾]

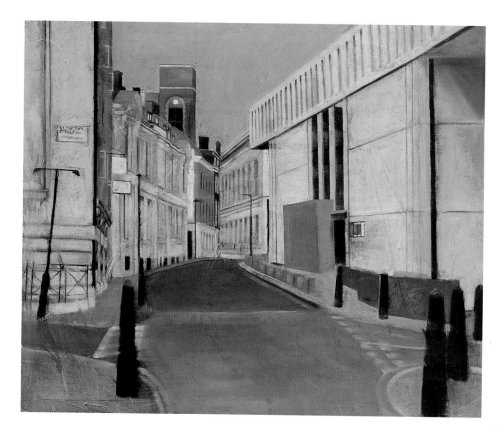

40
Orange Street, WC2
1994

Oil on linen
167 × 202.5 [65¾ × 79¾]

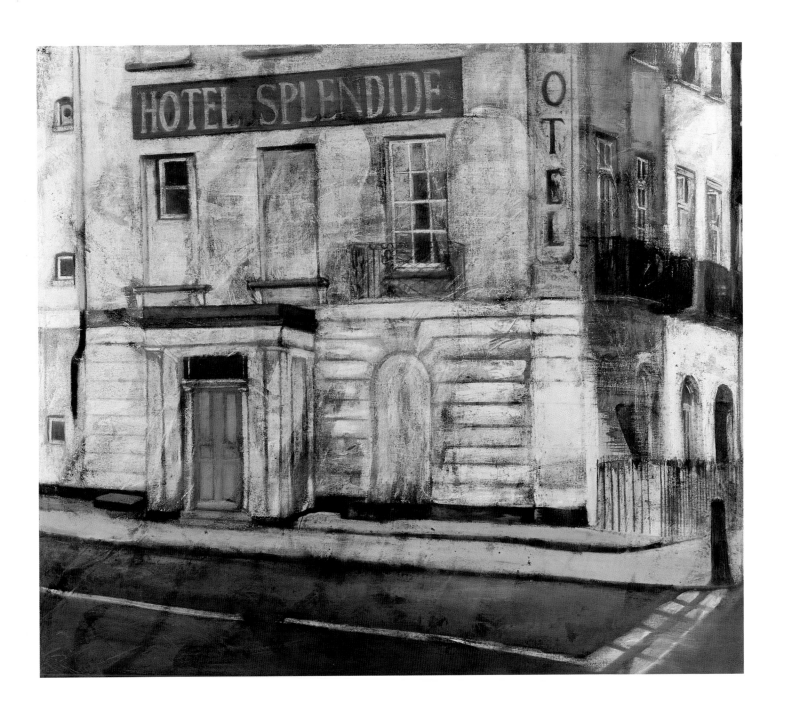

41
Hotel Splendide
1994

Oil on linen
182.9 × 213.3 [72 × 84]

42
Royal College Street,
NW1
1994–95

Oil on linen
152.4 × 207 [60 × 81½]

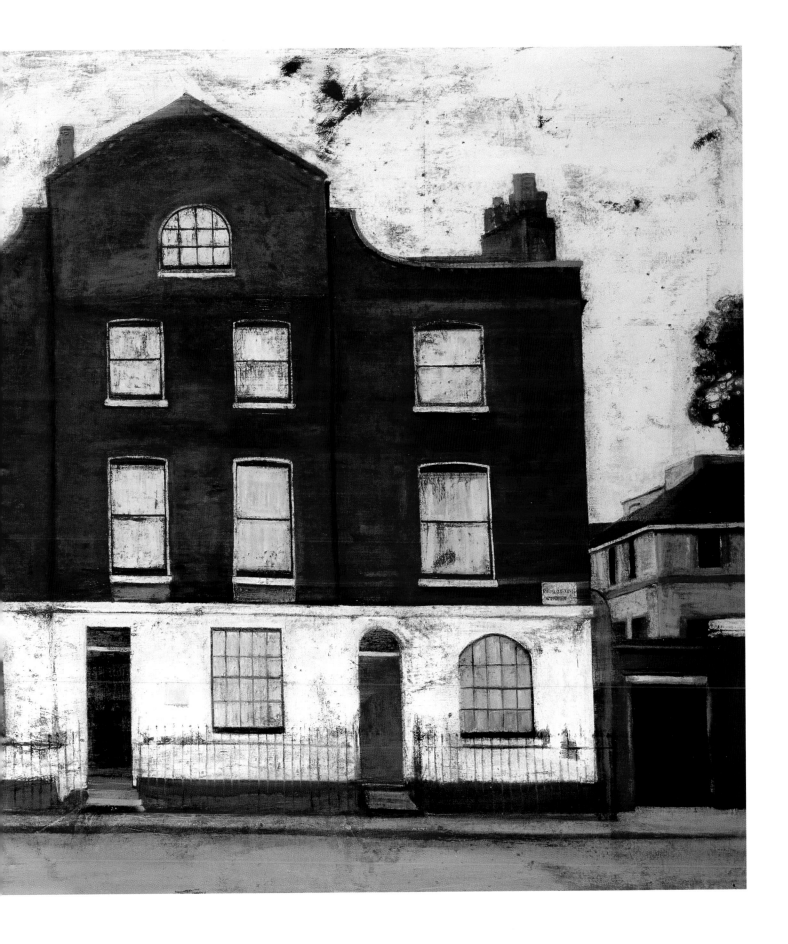

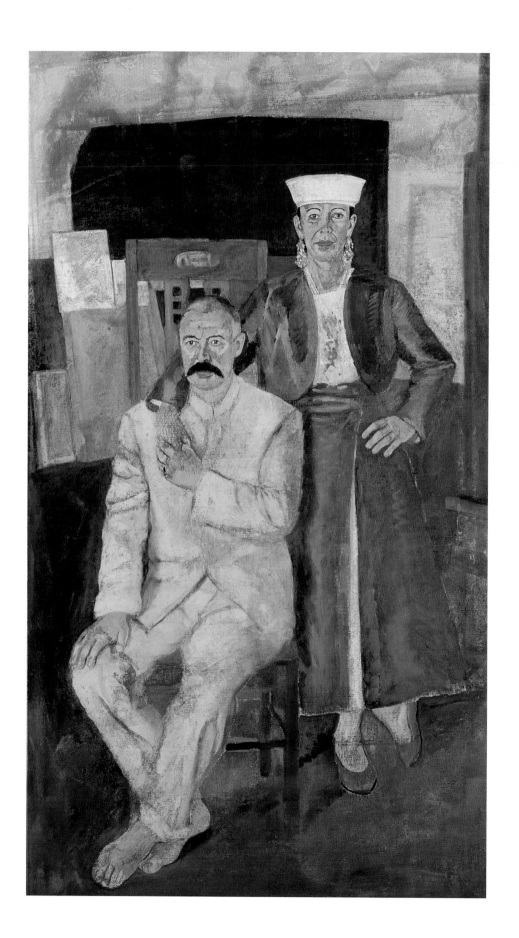

43
Marriage Portrait: John
Goto and Celia Farrelly
1994

Oil on linen
203.2 × 114.3 [80 × 45]

44
Sir Richard Doll
1996

Oil on linen
50.8 × 40.6 [20 × 16]

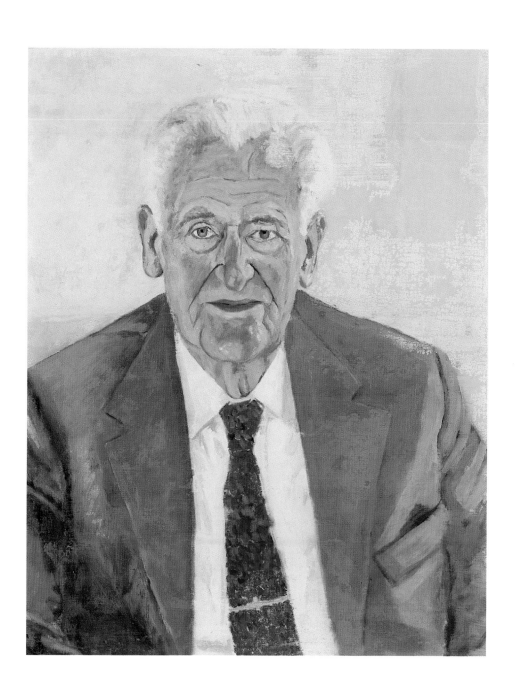

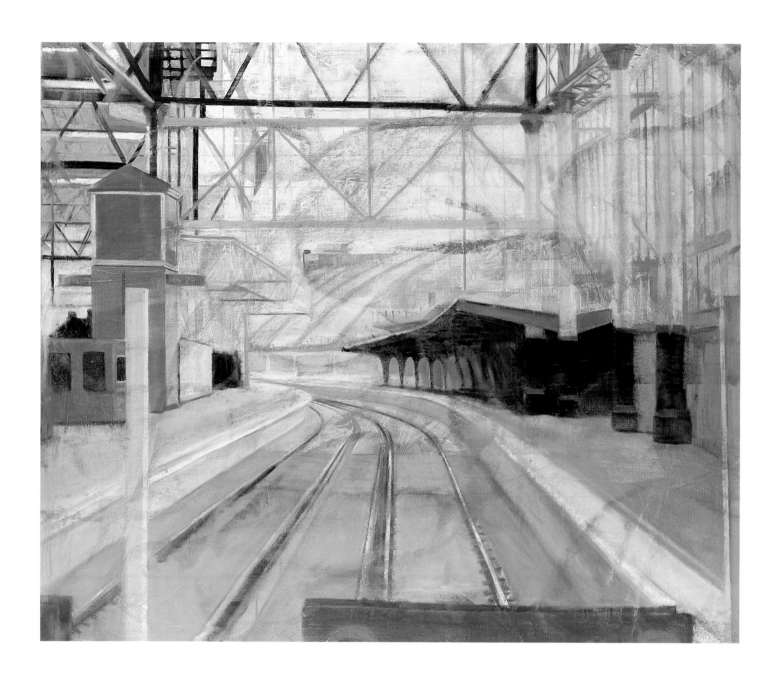

45
Waterloo
1994–95

Oil on linen
167×202.5 [$65\frac{3}{4} \times 79\frac{3}{4}$]

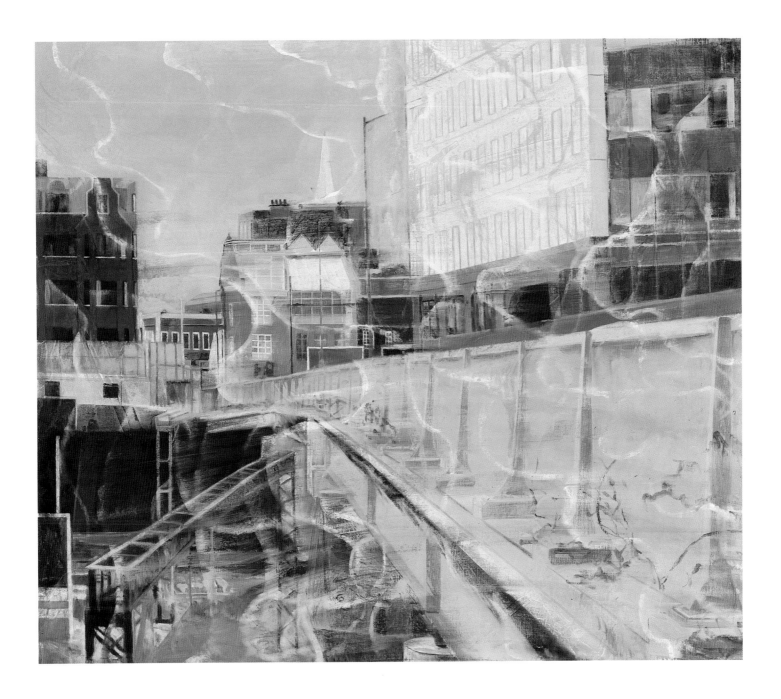

46
London, EC2
1995

Oil on linen
190.5 × 221 [75 × 87]

47
Italian Cast Room,
Victoria and Albert
Museum (Laocoön)
1995

Oil on linen
152.4 × 207 [60 × 81½]

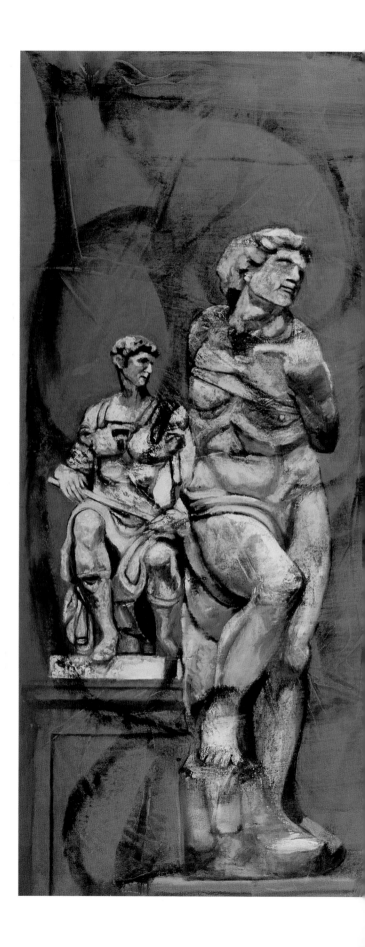

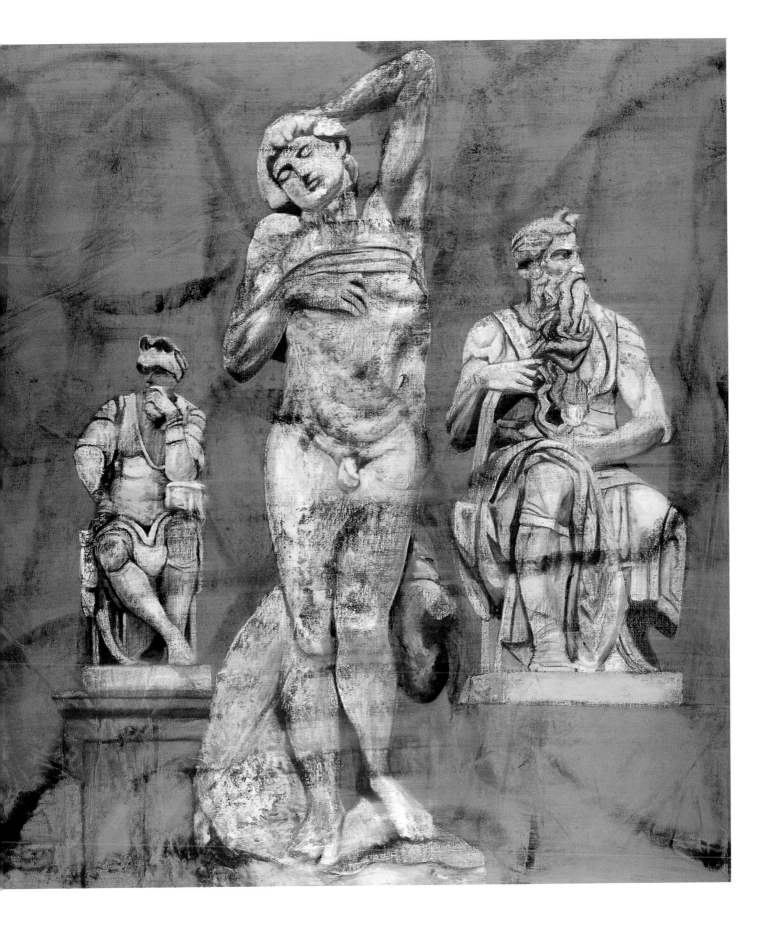

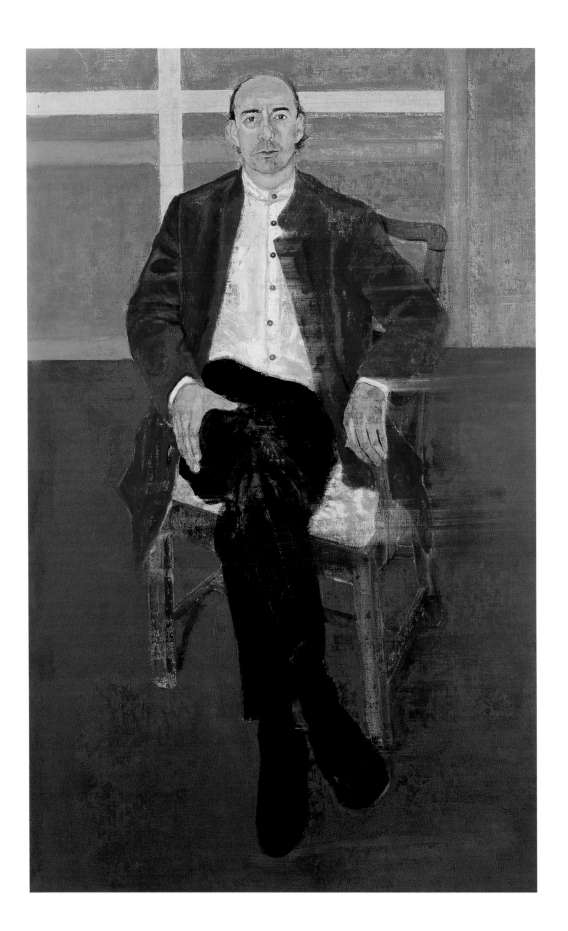

48
Neil Addison
1996

Oil on linen
154.9 × 97.8 [61 × 38½]

49
Counterproof of Neil
Addison
1996

Oil on Japanese paper
Image size 154.9 × 97.8
[61 × 38½]

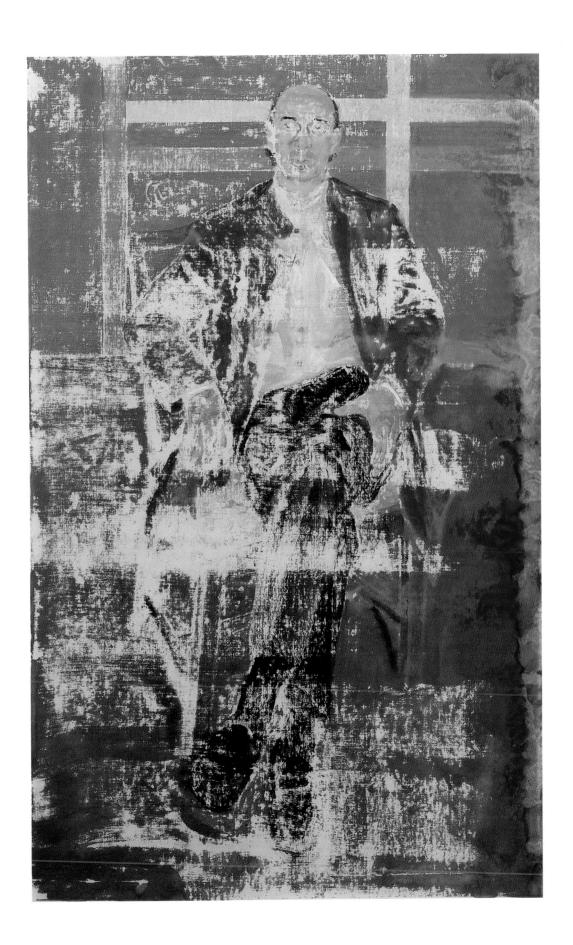

All artists progress by reacting to the work of their predecessors. Some do so violently and break the mould in a spirit of rebellion, while others, more subtly perhaps, indulge in subversion and adopt a Trojan Horse approach. Both reactions can be found in nineteenth-century France, where some of the most radical artists – Manet, Degas, Seurat, Cézanne – used tradition as a springboard. Their strategy was not so much to conceal their sources as to turn them to their own advantage. Basically, it is a question of artists remaining true to their *sensations* as opposed to following fashion. Camille Pissarro, who had first encouraged Gauguin to paint during the early 1880s, had by the 1890s become suspicious of the younger man's motives, believing Symbolism to be nothing more than an artistic expedient. In a letter of 20 April 1891, written to his eldest son, Pissarro accused Gauguin of being a "schemer" and not a "seer".

Arturo Di Stefano's modernism stems not from what he rejects, but from what he accepts. The novelty comes from an individual response to a living tradition, which involves a rearrangement of the parts and ultimately a reshaping of the whole. Arturo Di Stefano rearranges the cityscape, accepts the challenge of pastel, and tilts at famous compositions. In *Marriage Portrait: John Goto and Celia Farrelly* (pl. 43), for example, the viewer's chief point of reference is Jan van Eyck's *The Arnolfini Marriage* (London, National Gallery), but while Arturo Di Stefano balances the private against the official (or public) and the exotic against the reserved, he is, more significantly, also reversing the hierarchy – simply by transposing the rôles of man and wife.

Igor Stravinsky in music, George Balanchine in dance, Peter Brook in theatre, T.S. Eliot in poetry: these are distinguished examples of radical reinterpreters of traditional forms and themes. Richard Eyre, who as a former Director of the Royal National Theatre was also a habitué of the South Bank, has written in his autobiography *Utopia and Other Places* (1994), in the context of drama, that "the classics survive not because they are relics venerated for their age but because of what they mean to us *now*". They are, he writes, "our means of decoding the present". It is in this way, Eyre asserts, that "the past is consistently made to serve the needs of the present". Similarly, for painters such as Arturo Di Stefano, respect for traditional values in art – epitomized by the discipline of good drawing, knowledge of perspectival and colour theory and a sophisticated technique – offers a way forward, as opposed to a cul-de-sac, because it provides the means – conceivably the only legitimate means – of expressing the new.

50
Penguin House
1997

Oil on linen
170.2 × 221 [67 × 87]

with surprising clarity. The surface, therefore, is the result of an optical pullulation that on some occasions can seem veiled and on others transfixing.

Another departure in Arturo Di Stefano's fascination with technique is his use of pastel. He made a number of portraits and still lifes in this notoriously exacting medium in 1994, relishing its luminosity as opposed to its opacity. In this respect his images reach back to the eighteenth century, with their clearly demarcated areas of colour, generous backgrounds and adherence to crisp details. The surface of these pastels is intensely smooth, almost burnished, and Arturo Di Stefano seems keen to deny the purely physical attributes of the medium. This is the world of Liotard, Quentin de La Tour or Perronneau, and it is far removed from the resolute handling preferred by Degas and Redon, for example, who emphasized the crumbly, varied texture of pastel.

The portraits in pastel were preceded by a series in oil. The variety in these is derived from different backgrounds, placement in the picture space and personality expressed through physiognomy or dress. The small portraits are of head and shoulders only, and the format in this respect recalls Greco-Roman painted portraits, which are in turn dependent upon Egyptian memorial images attached to mummies. Viewed together they resemble a set of variations on a theme, as in music, but they can also be seen independently, as in the case of the portrait of Sir Richard Doll (pl. 44) officially commissioned by the National Portrait Galley, London, in 1996. Full-length portraits, such as the beguiling, Watteauesque image of the artist's wife, Jan (pl. 24), are relatively rare in Arturo Di Stefano's œuvre. The portrait of Kim Butteriss (1994) is therefore a remarkable achievement. It is an image of composure (as in Raphael), of linearity (as in Ingres) and of rich tonality (as in Matisse). Yet it is decidedly not an eclectic portrait, since the individuality of both artist and sitter remains intact.

The extensive body of work by Arturo Di Stefano that now exists prompts some observations of a general nature – albeit of a tentative kind. All aspects of his art seem delicately balanced between the past and the present; indeed it evolves out of a dialogue between the past and the present. It is from this dialogue that tension is derived, interest quickened and beauty manifested. Expressed in this way, the work of Arturo Di Stefano might easily be dismissed as guileless or predictable, because it is founded on tradition, but in fact the images he creates – and the way in which they are produced – are strikingly modern. Although he acknowledges the past, it is not in a mood of awe, like Fuseli's *The Artist in Despair over the Magnitude of Antique Fragments*. Rather, as Cézanne wrote to Roger Marx on 23 January 1905, "To my mind, one does not put oneself in place of the past, one only adds a new link". In this respect, paintings in Arturo Di Stefano's œuvre that veer towards the abstract are particularly apposite in partaking of tradition and yet being removed from it. *Stairs, Stedelijk Museum* (1997), *Stedelijk Museum, Amsterdam* (pl. 57) and *85 Rokin, Amsterdam* (pl. 58), a triptych conceived in connection with the artist Beckmann, together with *Cell* (2000), which puts the viewer in mind of Shakespeare's *A Midsummer Night's Dream*, are apodictic in their power of observation and the conviction of their execution.

Sense of place and awareness of tradition are not the only notable aspects of Arturo Di Stefano's art. A highly unusual and specially evolved technique provides an extra dimension that gives added meaning to the pictures. The artist does not apply the same technique to every picture he paints, but in several paintings he uses a method of facture that is strikingly individual and is derived from his considerable experience as a printmaker. There are three stages to this process. First, the overall design, having been laid in, is deliberately blurred or partially obliterated by broad striations made with the brush in a local colour. Second, the surface of the whole picture is covered in a thick layer of varnish. Third, pieces of paper (originally newsprint) of varying sizes are applied to the painting to soak up the varnish, like blotting paper. The removal of these pieces of paper has the effect of smudging or even removing the paint – certainly altering its appearance – so that an additional pattern is imposed upon the design. A refinement of this technique involves the use of Japanese woodblock paper, which comes in larger sizes than newsprint and is stronger, therefore allowing the artist to make a counterproof of the picture that can in turn be preserved. The process has been vividly compared to peeling off a bandage to expose a fresh wound.

Arturo Di Stefano first experimented with this technique in Turin in 1986. It was inspired by the Turin Shroud and the Veil of St Veronica already referred to. Significantly, the first example of his art to use this technique was the series of twenty or so writers' portraits entitled Sudaria, beginning with Franz Kafka. The actual process, however, is also closely allied to printmaking methods such as *retroussage* (the lifting of ink from recessed lines of the printing plate as it is wiped across the surface) and a great deal depends on what might be described as controlled accident. The artist himself finds the technique liberating, because there is always a sense of danger as events overtake him. There is also a subversive element in that the surface of a painting is normally the result of a slow, almost ruminative, certainly additive process, whereas Arturo Di Stefano is regularly forced to improvise at a late stage, thus creating painted surfaces with broken, disjointed rhythms and surprising patterns that sometimes act as a counterpoint to the original design. It is an impulsive, random method of painting that makes a vivid contrast with the almost meditative assessment of the motif before work begins on the slow building-up of the painted surface.

The expressive quality of this technique adds an exciting dimension to Arturo Di Stefano's compositions. The agitation of the trees in *South Bank*, for example, creates an atmosphere that stems from the dynamics of nature, supplemented by the marks imposed on the surface by the blotting process. Similarly, in *Hotel Splendide*, *Royal College Street, NW1* or *Crucifix Lane, SE1,* the crumbling texture of the buildings is achieved not only by the texture of the paint itself, but also by its actual removal or blurring as a result of blotting. Even more important is the relevance of this technique to the subject-matter that most interests the artist, namely the part that memory or recollection plays in the exercise of picture-making. Sections of his compositions, as in *Enceinte I.M. GDS, KK* or *Refuge*, are sometimes blurred or out of focus – just as memories are fragmentary or indistinct – whereas other parts are realized

Different sources of inspiration combining Anglo-French connections are evident in *Hotel Splendide* (pl. 41) and *Royal College Street, NW1* (pl. 42), painted in 1994 and 1994–95 respectively. These are motifs teased out of the urban spaces of Camden Town. *Hotel Splendide* is in reality a visual trick, for this is not a building in France but in Mornington Crescent, close to where Sickert lived and near where Frank Auerbach has a studio. The building, situated on the corner of a street leading off the crescent, was apparently once adapted for a film set and, although inhabited today, is still emblazoned with the name of the hotel. On closer inspection, the street markings and the architectural features indicate a British location. *Royal College Street, NW1* depicts a building that does not obviously belong to the English architectural tradition. The flat form of the frontage resembles a church façade designed during the early Italian Renaissance according to the principles of Alberti. A plaque, however, records that this is the house in which Arthur Rimbaud and Paul Verlaine lived while in London in 1873. The road was then called Great College Street and the house was no. 8.

The structures in both *Hotel Splendide* and *Royal College Street*, *NW1* show the effects of time. The paintwork is peeling, the balconies and railings are loose, the alterations belie the original purposes of the architecture. All of this the artist observes, while exercising a firm control over the rigid allocation of verticals and horizontals, punctuated by a series of round-headed windows, arches and blind niches. A sense of decay, which is by no means characteristic of the area as a whole, does pertain to these two motifs, but the artist has used the ageing qualities of the buildings to his advantage, not only aesthetically in the sombre tonalities, but also in the technique. Similarly, when he came to paint the elegy to his studio *Demolition Site, Mill Street, SE1* (pl. 68), the technique informed the image; in the artist's own words, "dry scumbling to mimic the dusty destruction and the coarse bristle of the brush to describe the rubble." *Crucifix Lane, SE1* (pl. 38) partakes of the same qualities.

The marked individuality of Arturo Di Stefano's exploration of the cityscape finds further expression in *Penguin House* (pl. 50). Although John Ruskin once wrote to his American follower Charles Eliot Norton that "one can't be angry when one looks at a penguin", this painting has a darker meaning. The artist himself points out that the Penguin House in London Zoo "is a home for those creatures away from home, designed by a foreigner (Berthold Lubetkin) driven from his homeland, and that the scene has been painted by the son of an immigrant who left his place of birth to settle in this country". *Penguin House* alludes to exile and loss, but contrasting with it are two paintings of Coram's Fields in Bloomsbury, the site of the Foundling Hospital established by Sir Thomas Coram in 1746. *Camera Lucida* (pl. 56) and *Coram's Fields* (pl. 64) include the artist's own son playing in the urban environment. They are prelapsarian images – joyous in their punning references to paintings by Piero della Francesca and optimistic in their emphasis on innocence. Many of the cityscapes explored by the artist in his life so far resonate with possibilities, to the extent that – as in *Tuileries Gardens, Paris* (1998) and *Arcade, Paris* (1998) – he has begun to return to them in order to continue the investigation.

Di Stefano is contrasting a shadowed side street with a main thoroughfare. The subjects of both these pictures are not obviously related to the artist's awareness of the European visual tradition, but once the buildings are identified as repositories of art, their significance for the painter becomes even more poignant.

Italian Cast Room, Victoria and Albert Museum (Laocoön) (pl. 47) takes its cue from the brooding figures outside the Walker Art Gallery, but moves inside museum space and poses casts of famous sculptures in a highly selective and witty juxtaposition. Only in a room full of casts could an imaginary dialogue of this type be contrived. The artist here seems to poke fun at his own sense of tradition, in the sense that casts are duplicates of originals made to serve the purpose of encouraging good draughtsmanship – a practice that is ultimately negated by the fact that casts are divorced from their primary contexts.

Arturo Di Stefano's exploration of the cityscape continues in London on the south side of the River Thames. *South Bank* (pl. 39), like *Pool of London* (pl. 63), is a traditional view of a type essayed by painters such as Canaletto and Daubigny, further explored in the work of Monet, Derain and Kokoschka, among others. The tones of *South Bank* – blue, imperial green and viridian green – are high pitched. As in *William Brown Street, Liverpool*, the recession into depth is established by the parallel placement of the trees and lampposts garlanded by decorative rows of light bulbs. The view partakes of a hierarchy extending from pure nature, as represented by the trees, to the architectural achievements of Sir Christopher Wren, embodied in St Paul's Cathedral, while also embracing industrial art in the form of the elaborate lampposts. *South Bank*, however, also indulges in displacement, for out of the composition to the right is the cultural complex extending to the east of the Royal Festival Hall, a range of buildings that includes the Hayward Gallery, the National Film Theatre and the Royal National Theatre.

Behind this South Bank complex, across York Road, is Waterloo Station, opened in 1848 and now an international terminus for the Channel Tunnel services to Paris, Brussels, Lille and Calais. *Waterloo* (pl. 45) pays homage to the light, airy fabric with a curved roof recently built to a design by Nicholas Grimshaw as a terminus for the Eurostar rail network. The scene is flooded with light, in which the metallic framework of the structure, rendered in grey-blacks and yellows, positively dances, while red accents articulate the recession into depth already traced by the rails of the curving track. The smoke-filled atmosphere of the Gare Saint-Lazare captured by Monet is far removed from the technological revisionism of this modern railway station. If Goethe called museums temples of art, the great railway stations of the early nineteenth century, it has been said, are the cathedrals of technology. There is a personal aspect to this picture, since Waterloo Station has only recently become the new (if temporary) gateway to Europe. The railway lines lead back to the mainland of Europe through France and beyond to Italy, where the artist has his roots. The sense of emptiness following departure here, therefore, is not one of loss, but more one of hope or escape.

concentration of such motifs. One of these paintings depicts a motif in Liverpool, but the rest are of London, where Arturo Di Stefano now lives. They show how he comes to terms with his immediate, if adopted, surroundings. The series of six pictures entitled Studio (1991–93; see pls. 28, 31, 32) is essentially a rendering of private space, but the urban views unveil a commitment to public spaces that nonetheless retain a personal significance for the artist. This marks an exciting departure in Arturo Di Stefano's œuvre, and the fact that the paintings are on such a grandiose scale suggests an increasing confidence in the translation of ideas into images.

William Brown Street, Liverpool (pl. 37), painted in 1994, depicts one of the most famous panoramic views of the city, including the Neo-classical façade of the Walker Art Gallery, founded in 1874. It is not obvious at first sight that the building is an art gallery until it is realized that the statues who guard the entrance, like brooding presences, represent Raphael and Michelangelo. The glimpse of a blue banner hanging between the Corinthian columns prompts the viewer to imagine that something of interest may lie inside the building. This is a consummately structured composition: the façade of the art gallery is seen obliquely, so that its Neo-classical proportions require a carefully handled exercise in perspective. Again, as with *Bonito*, there is an absence of people, as though the artist deliberately resists including figures – unlike Tissot's depiction of the main steps of the National Gallery in London (*London Visitors*, c. 1874). Yet the measured tread of the street lamps extending along the front of the building, shadowed by accents of red, is in some ways a surrogate for the figures. For the artist, of course, the building has a special potency, and not simply because it forms part of a nexus of important buildings in the city of Liverpool. Goethe described museums as temples of art, and to a certain extent this picture is Arturo Di Stefano's homage to artistic tradition in the broadest sense.

Orange Street, WC2 (pl. 40), also of 1994, has similar connotations. Although they were not painted as a pair, there is a connection with *William Brown Street, Liverpool* insofar as the view along the street includes the back of the National Gallery in London. The entrance forms part of an extension to the gallery designed by the Ministry of Public Buildings and Works and opened in 1975. Arturo Di Stefano is not only attracted by the association of the building on the right with the great tradition of European painting, but also by the dips in the street and the somewhat wayward sight lines of the buildings, lampposts and bollards.

As in *William Brown Street, Liverpool*, the visual syncopation is eventually contained by the application of perspective, but once again the scene is devoid of human presence. Indeed, the absence of this element in the urban context veers towards the surrealistic world of Giorgio de Chirico, just as the tower silhouetted against the sky to the left of centre in *Orange Street, WC2* does not seem to belong to contemporary London, but to the world of Simone Martini, the Lorenzetti or Piero della Francesca. The tones of *Orange Street, WC2* are more restricted than those of *William Brown Street, Liverpool* – grey, black, ochre, yellow, off-whites and brown – perhaps because Arturo

Bonito, therefore, is a carefully structured composition in the same way that the tones are delicately nuanced with pink, ochre, brown and off-whites, all beautifully blended. The roof lines are silhouetted against an expansive blue sky, the luminosity of which is intensified by the strong accents of the green vegetation. Such a style of painting recalls work by Corot and Maillol wherein the precisely observed architectural vocabulary is translated in paint almost directly into abstract forms. What is evident is that for the artist, distant memories of Bonito have sharpened over the years, as opposed to becoming blurred. *Bonito* represents a change in focus in Arturo Di Stefano's output. Earlier works are characterized by an absorption in Greek mythology and a cast of inspirational figures from the worlds of literature, philosophy and art, rendered in a style that deliberately obscures or diffuses images in order to clarify meaning and to heighten revelation. In such works, also, it seems that the artist is still searching for a determinedly individual style and treatment of subject-matter.

It is not the case, however, that the artist has chosen to neglect or abandon any of his intellectual allegiances. For the moment they may seem no longer to be the principal subject of his pictures, but in fact Arturo Di Stefano elects instead to integrate them into his compositions by different means. He now proceeds by association as opposed to direct representation. This is what happens in the paintings *Enceinte I.M. GDS, KK* (pl. 71) and *Refuge* (pl. 72), which to all intents and purposes form a pair. These paintings, like the slightly earlier *Mending Wall* (pl. 69) and *Border* (pl. 70), are explorations of motifs in the immediate neighbourhood of the artist's studio at Bow. While *Mending Wall* and *Border* are essentially still lifes, replete with enigmatic meaning, combining the earthiness of Chardin with the geometry of Mondrian, *Enceinte I.M. GDS, KK* and *Refuge* advertise their personal associations. Attached to the new wall, surrounded by a white frame, in *Enceinte I.M. GDS, KK* is an image of Cézanne's family property known as the Jas de Bouffan. *Refuge* has a similar kind of Arcadian reference in its image of a hill town called Petralia Sottana in Sicily, where Arturo Di Stefano's father was born. The monolithic quality of all four of these compositions is relieved by the upper sections: open sky, barbed wire, an iron shed and a view of the artist's own studio. The intertwining of such motifs demonstrates how for the artist his surroundings are not simply items in his visual vocabulary, but also an expression of his personal anxieties, namely, in this instance, enclosure and escape. The viewer is held in thrall by the balance maintained between potentially threatening subject-matter and the exuberant tonality and textural viscosity of the paint surface. The range of hues in the sections of wall depicted in *Mending Wall*, *Border* and *Refuge* – ochre, orange, red, brown, purple – resemble flesh or raw meat as experienced in Stanley Spencer or Lucian Freud, whereas the creamy white lustre of the paint between each of the bricks recalls the striations in a painting by David Bomberg or Leon Kossoff. A fifth painting in the sequence is entitled *Château Noir, E3* (pl. 73).

A sense of place and a growing interest in urban themes emerged slowly in the artist's work, beginning in 1988–89. Turin, Venice, Paris and London have so far provided subjects, but only in 1994–95 has there been a

renders these portraits in a suitably ghost-like form, as though personally summoned by Arturo Di Stefano from the dead. Only during the 1990s, after homage had been duly paid to these forerunners, did the artist begin to paint his own friends, thus beginning the process of fleshing out and populating his own – so far somewhat cerebral – world. Concurrently, a sense of locus begins to emerge – Saint-Rémy, Turin, Venice, Paris, London – usually, at the earliest stages, devoid of people, with the architecture or, more often, a carefully selected motif of a particular building or view, dominating. Finally, and most evidently in the views of London, Arturo Di Stefano begins to explore the relationship between people and the spaces they occupy in work or play – a theme that perhaps awaits further exploration. The painting *Pier* (pl. 65), which includes the artist himself, his wife, son and friends, seen in the context of London, may in this respect be a prescient picture.

It is frequently claimed that memory – that is, the artist's own perception distilled by time – is the principal subject of Arturo Di Stefano's work. He searches the past, just as he looks at the landscape or the cityscape, for creative associations that allow him to interpret the present world.

In many ways Arturo Di Stefano's art is a process of distillation. A carefully selected motif is refined over a considerable period, often with reference to a recognizable and well-established tradition, but one that is invariably modified, indeed transformed, by the artist's own experience. Initial observations are filtered through time by the operation of memory, rekindled by a technique characterized by impulse and accident. It is not difficult to appreciate why Arturo Di Stefano admires the poetry of T.S. Eliot so passionately.

The painting *Bonito* (pl. 36) serves as a touchstone. It depicts the centre of a small southern Italian agricultural town in Campania, situated between Benevento and Avellino. Such towns possess a rich deposit of the commingling of several Mediterranean cultures dating from well before the Renaissance – Greek, Byzantine, Norman, Angevin, Hohenstaufen and Moorish. The round tower with its pierced walls dominating the painting symbolizes the early history of Bonito, although now the building is used as a dovecote. For the artist, however, the town has a personal significance, for it was his mother's birthplace, and relatives still live there. The painting is a product of childhood memories reinforced by postcard images. The area shown is, in effect, the centre of the town and is used in summer as an open-air cinema. It is a place where local people congregate, although in the painting, as in the closing moments of a film by Federico Fellini, the inhabitants have mysteriously evaporated. In the artist's mind, however, it is the juxtaposition of architectural shapes that has impinged itself upon the eye. The buildings are locked together on two diagonals leading in one instance from the repoussoir motif of the tree across to the tower, and in the other along a street that meanders through the town. Although not in the centre of the canvas, the tower, with its distinctive pepper-pot shape, is clearly the principal architectural form, its presence challenged only by the tree.

reborn inner city is saluted by the plaintive cries of children playing in neighbouring school yards.

Just as important for Arturo Di Stefano's work is his family. Significantly, the studio at Bow is within walking distance of home, and, although members of his family do not appear regularly in the paintings, a preoccupation with ancestry, childhood and emotional or intellectual development is central to his work. Memories of time and place in the artist's own upbringing act as a catalyst, but also remain relevant in his concern for the plight of the world that his own son will inhabit.

Arturo Di Stefano's work has been included in numerous group exhibitions throughout Europe. He was a John Moores Prize-winner in 1991 and had a mid-career retrospective at the Walker Art Gallery, Liverpool, in 1993, which received a great deal of attention from leading critics. Discussion of his work has centred on two aspects: subject-matter and technique. From this there has emerged the acknowledgment that here is a total artist whose work is underpinned by a genuine intellectual enquiry, revealing an awareness of tradition but not afraid of experimentation. Part of the excitement of the work is the paradox of its visual accessibility compared to the thought processes that inspire the images. The visual intentions, or meanings, of Arturo Di Stefano's paintings lie on the surface, even if the references within them are sometimes obscure, personal or learned. The application, or translation, of the inspirational sources is usually transparently clear.

Arturo Di Stefano's success as an artist – the respect he has gained from those who have come to know his work – has been in part the result of a slow development by today's standards. It has been a process of maturation, as opposed to a series of moments of instant revelation, but even more important is the fact that the artist operates in a world of shared cultural experience. Private references for Arturo Di Stefano are couched in terms of a public heritage of literature, landscape and topography. It is the tenor of the internal dialogue in his work that appeals to the viewer, absorbing minds and engaging eyes. The conflation of literary, art-historical, photographic, theatrical and cinematic sources has an immense appeal, not least because they are intertwined with the artist's own personality, giving his work a pronounced autobiographical element devoid of solipsism.

Insofar as one can legitimately categorize Arturo Di Stefano's paintings, they fall roughly into four chronological groups. Mythological themes inspired by Homer, Virgil and Ovid come first (1981–86). These are followed (1986–90) by a series of figure subjects with the generic title Sudaria (all of them portraits of writers), Pall and Carphology, each inspired by two famous religious artefacts: the handkerchief with which St Veronica wiped Christ's face during the carrying of the cross to Calvary, and the Turin Shroud, which is said to bear the imprint of Christ's body following his burial after the Crucifixion. These figure subjects culminate in a group of portraits (1989–90) of artists, painted from photographs, including Degas, Monet, Cézanne, Sickert, Bonnard, Munch, Beckmann and Malevich. The technique employed

CHRISTOPHER LLOYD

An Appreciation

Bernard of Chartres used to say that we are like dwarfs on the shoulders of giants, so that we can see more than they, and things at a greater distance, not by virtue of any sharpness of sight on our part, or any physical distinction, but because we are carried high and raised up by their giant size.
JOHN OF SALISBURY, *Metalogicon* (AD 1159), Book III, Chapter 4

Although the name might suggest otherwise, Arturo Di Stefano was born in Huddersfield in Yorkshire in 1955, the son of immigrant Italian parents. A foundation course at Liverpool Polytechnic (1973) was followed by further training at Goldsmiths College, London (1974–77), and the Royal College of Art, London (1978–81). Subsequently he spent a year at the Accademia Albertina in Turin (1985–86). On the whole, however, Arturo Di Stefano has been based in London since 1974, where he has had three studios: at Jacob Street Television and Film Studios off Mill Street near Tower Bridge, where some of his work was destroyed by fire in early 1987; at Delfina Studios in Bermondsey Street in Southwark; and in Bow in one of the buildings (a tanning factory dating from the 1920s) converted by Acme Studios.

For Arturo Di Stefano, the studio is central to his activities. It is in part a place of action, but primarily one of contemplation. The paintings and prints of the studio at Mill Street, which no longer exists, having been surrendered to the developers in 1995, are intensely moving evocations of a Prospero's cell. By contrast, Di Stefano's present studio at Bow presents numerous views from its windows – a landscape dominated by industrial archaeology, but one also offset by the fresh shoots of social regeneration. Here, gasometers, moored barges and urban foxes scouring abandoned buildings are confronted by new recreation grounds, sports facilities and renovated schools. The spirit of the

Pharos (*detail*)
1999

Oil on Japanese paper
Image size 152.4 × 167.6
[60 × 66]

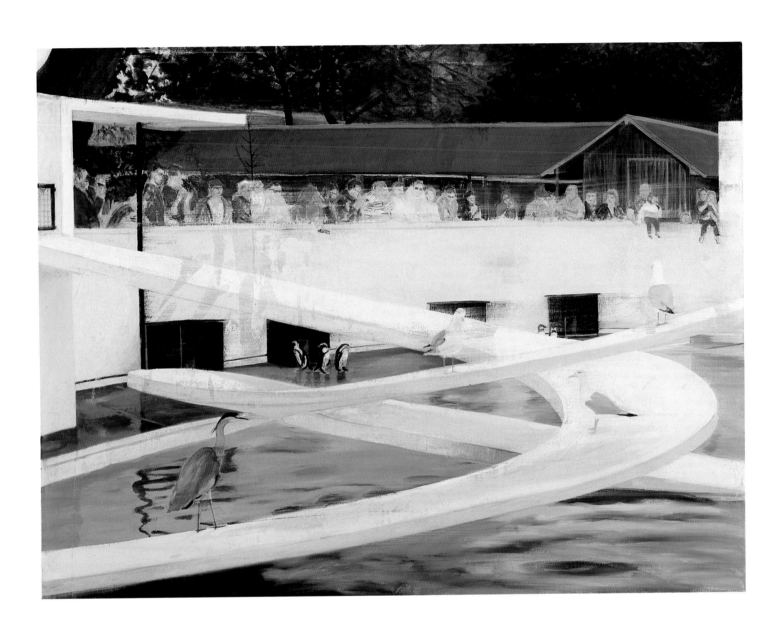

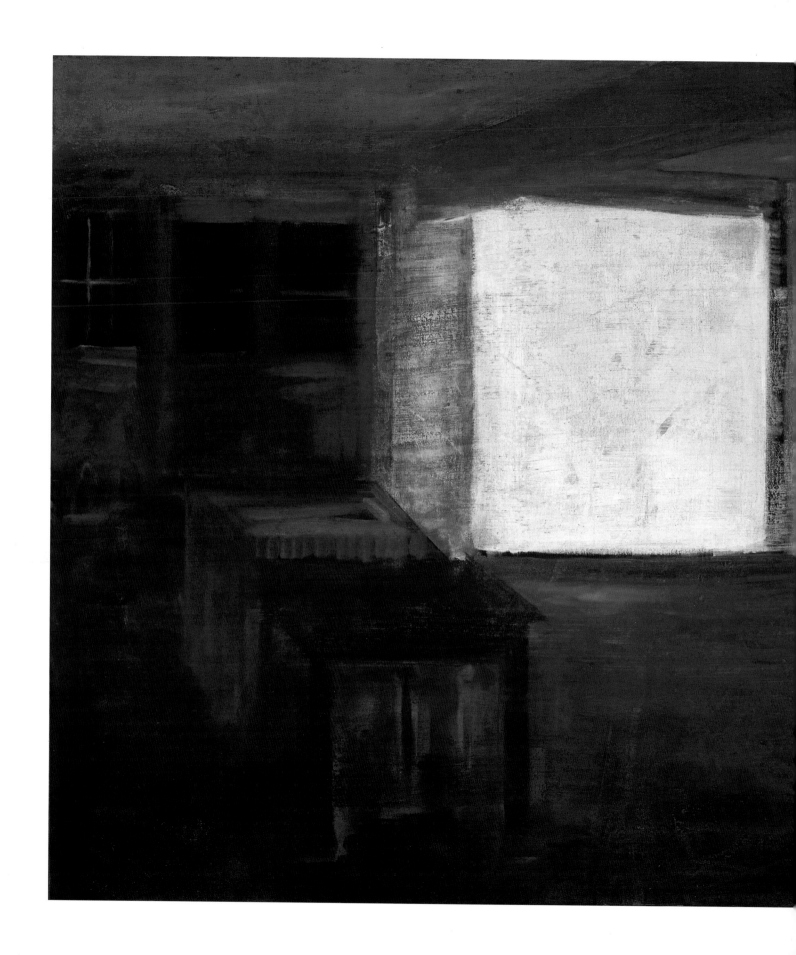

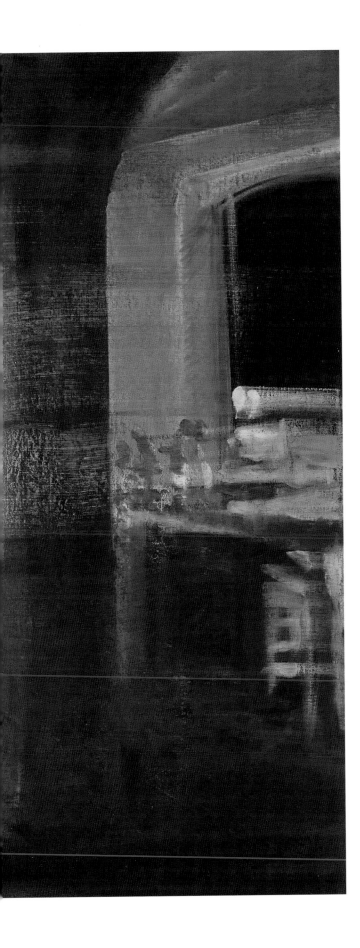

51
Adytum
1997

Oil on linen
118.1 × 163.2 [46½ × 64¼]

52
Adit (Camera Obscura)
1997

Oil and graphite on linen
157.5 × 208.3 [62 × 82]

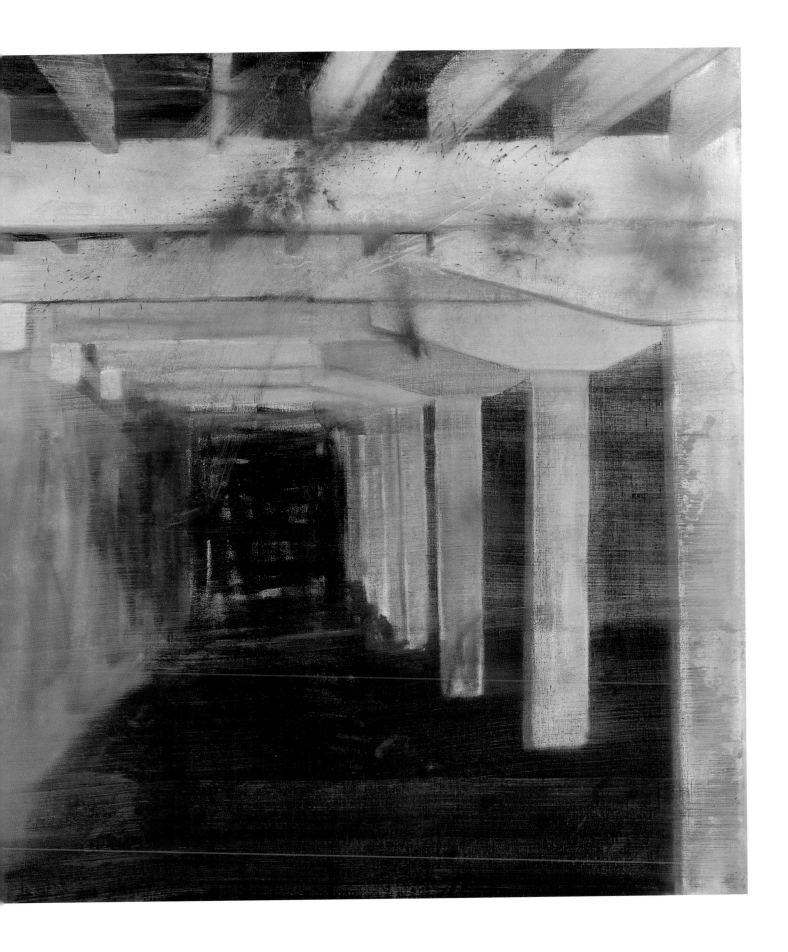

53
Muleta
1997

Oil on linen
73.6 × 55.9 [29 × 22]

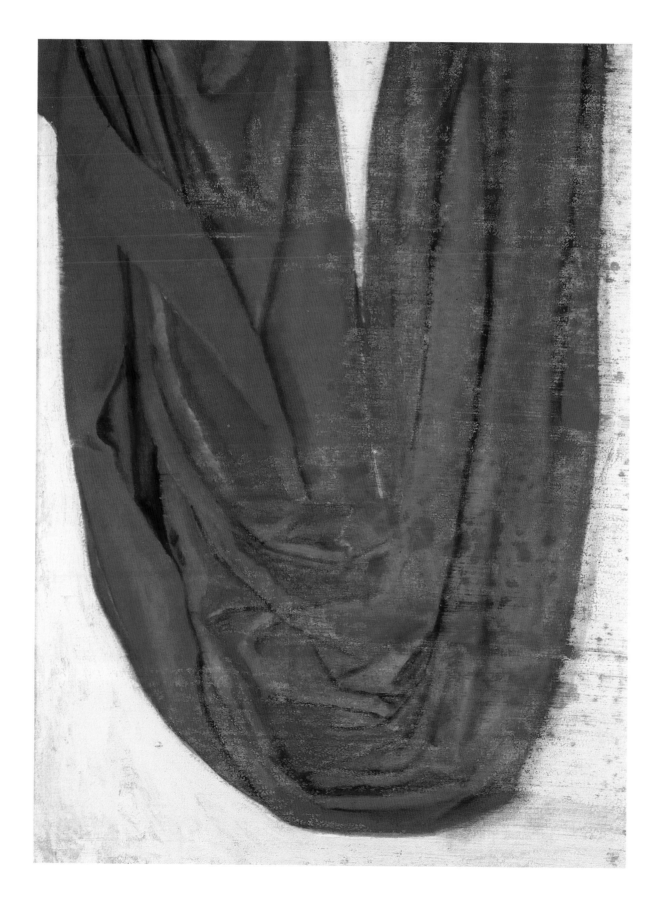

54
Veronica
1997

Oil on Japanese paper
Image size 73.6 × 55.9
[29 × 22]

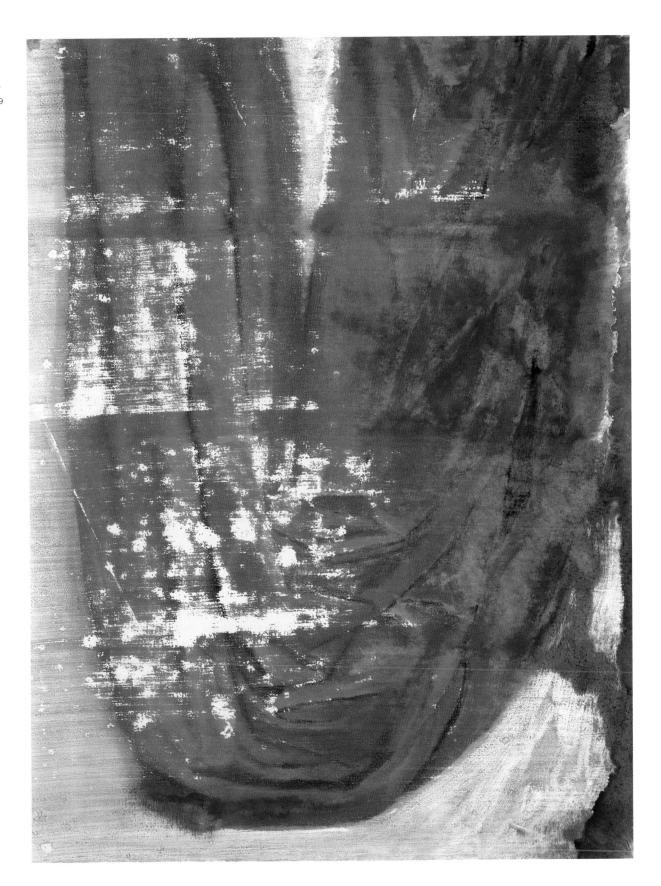

55
Stairs, Provence
1995

Oil on linen
203.2 × 121.9 [80 × 48]

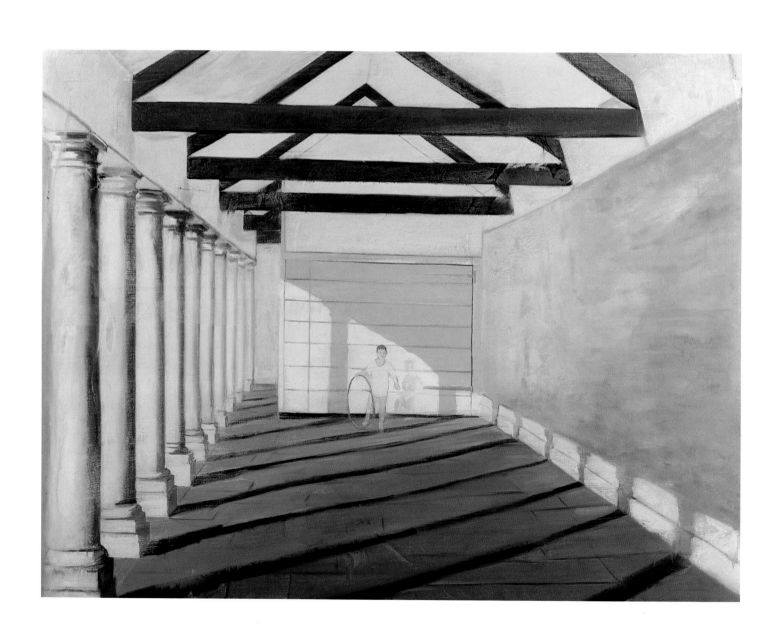

56
Camera Lucida
1997

Oil on linen
157.5 × 208.3 [62 × 82]

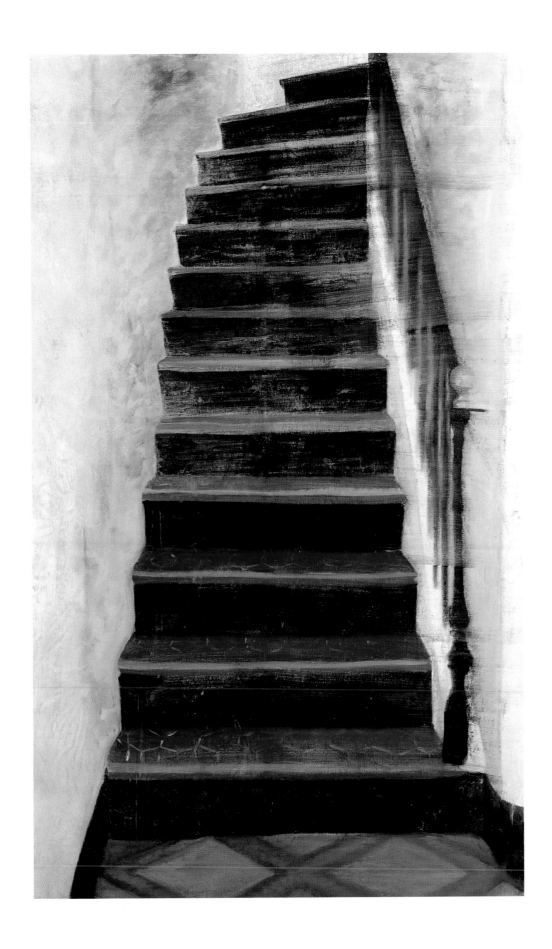

57
Stedelijk Museum,
Amsterdam
1996

Oil on linen
203.2 × 137.1 [80 × 54]

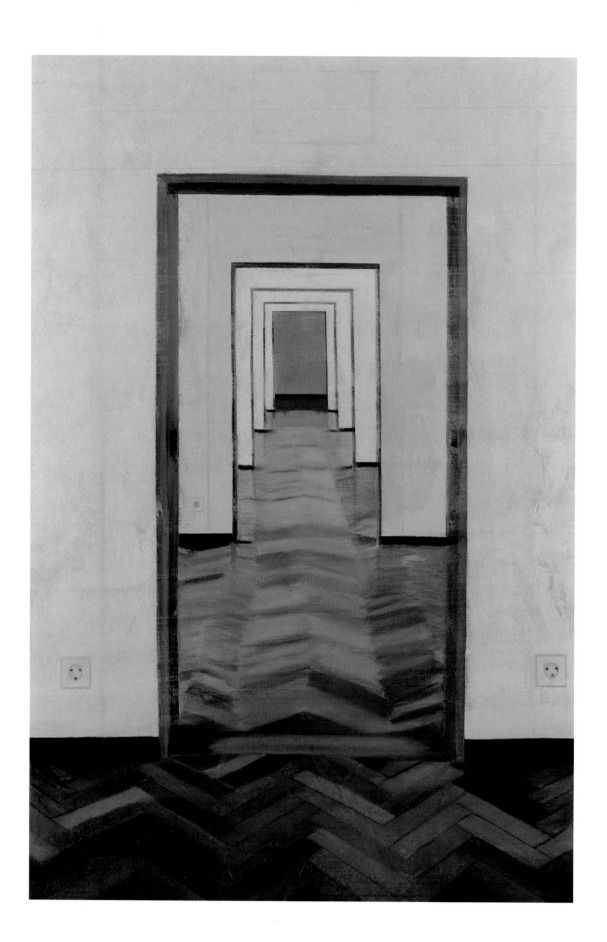

58
85 Rokin, Amsterdam
1997

Oil on linen
203.2 × 121.9 [80 × 48]

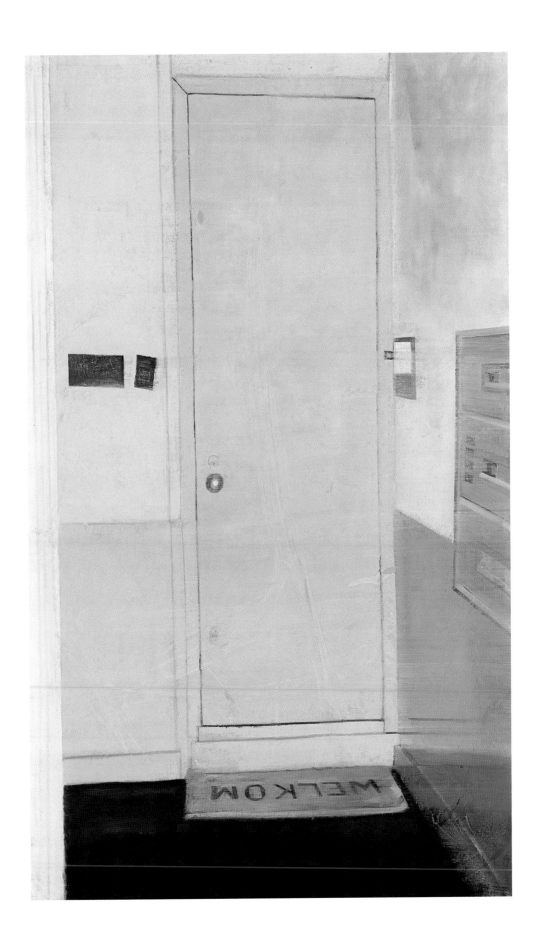

59
Nice
1997

Oil on linen
60.9 × 71.1 [24 × 28]

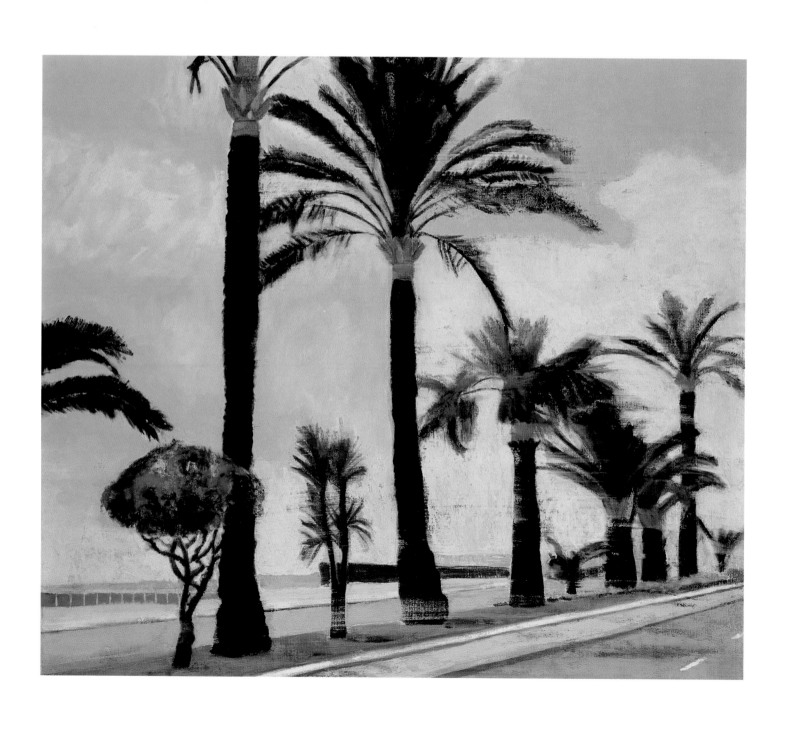

60
Mirage
1997

Oil on Japanese paper
Image size 60.9 × 71.1
[24 × 28]

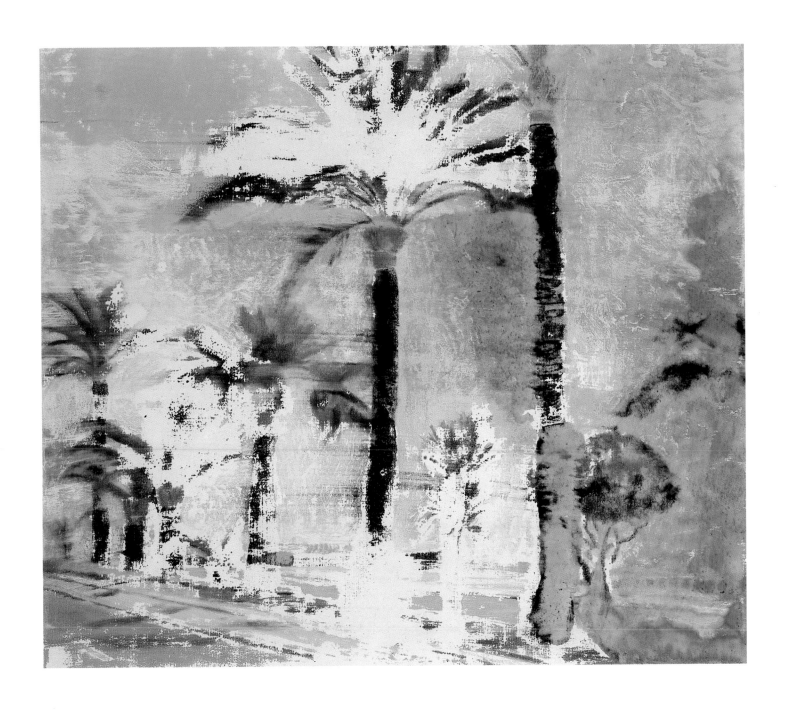

61
Passage
1998

Oil and wax on linen
163.2 × 118.1 [64¼ × 46½]

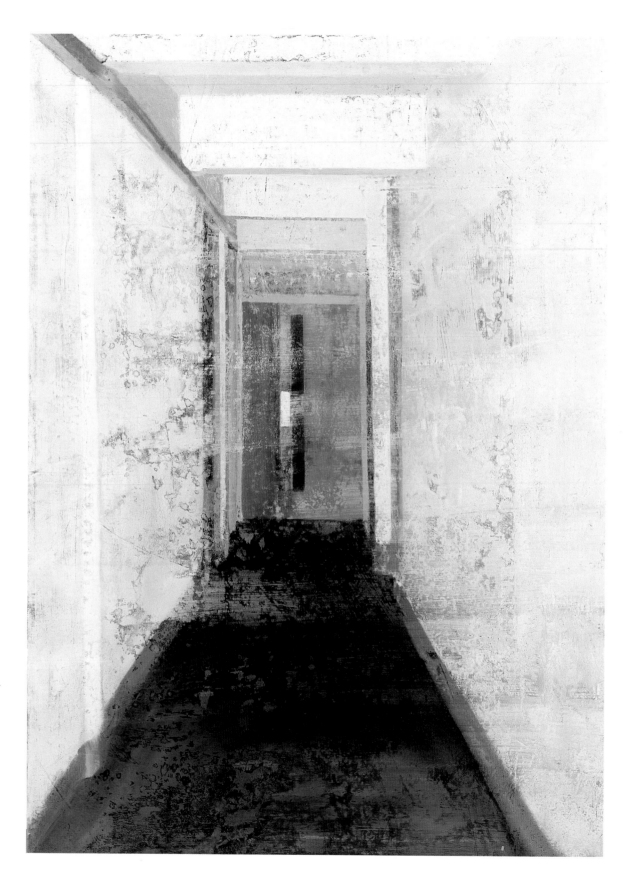

62
Limen
2000

Oil on linen
162.5 × 116.8 [64 × 46]

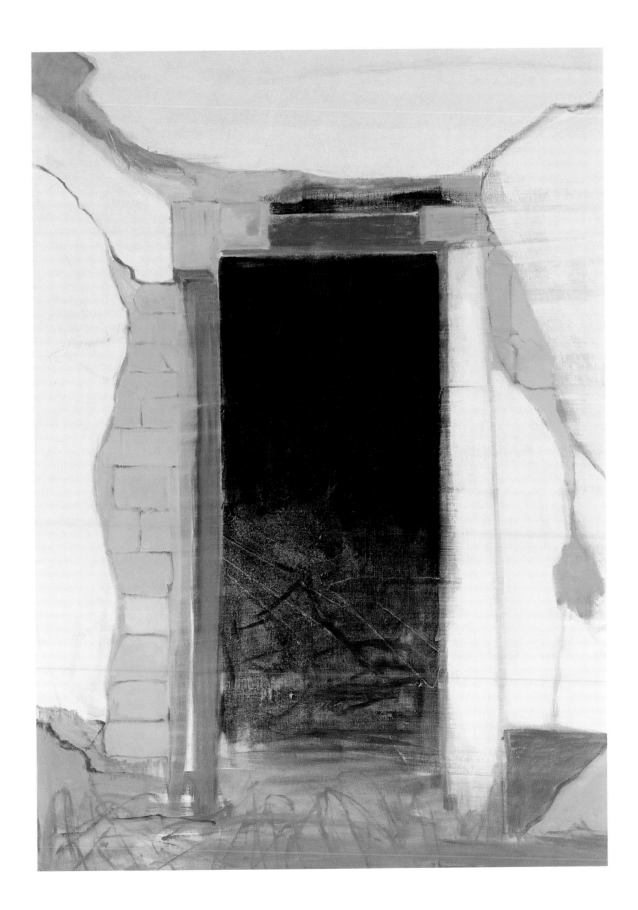

63
Pool of London
1998

Oil on linen
151.1 × 212.1 [59½ × 83½]

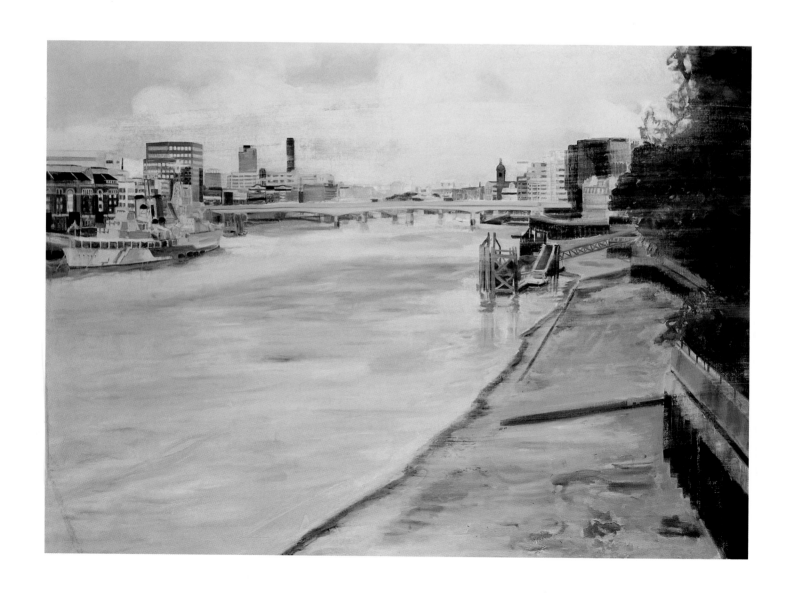

64
Coram's Fields
1998

Oil on linen
151.1 × 212.1 [59½ × 83½]

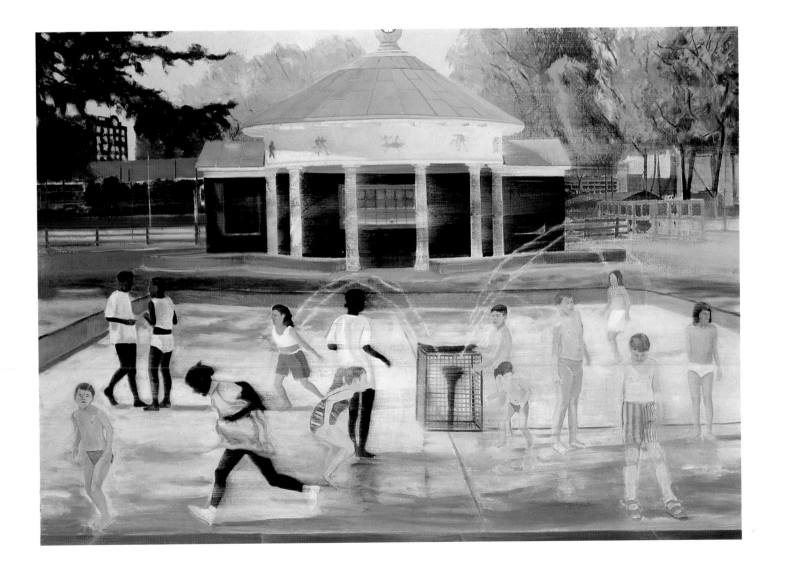

65
Pier
1998

Oil on linen
182 × 242.9 [71⅝ × 95⅝]

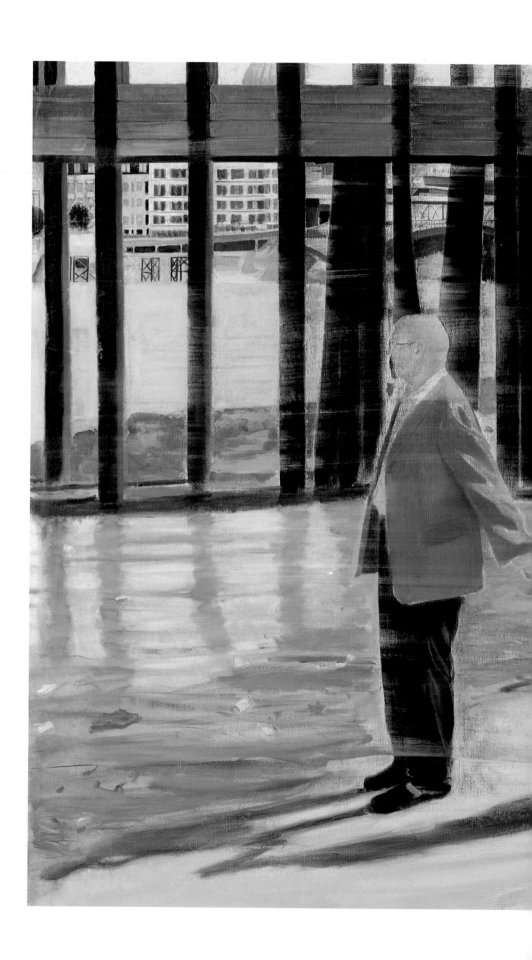

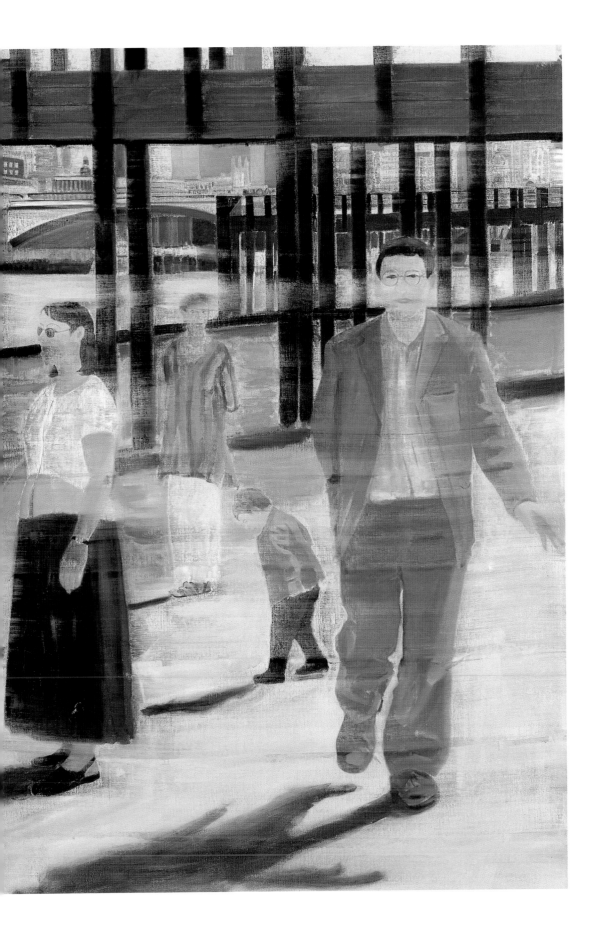

66
Stairs, National Gallery,
London
1998

Oil on linen
144.8 × 97.8 [57 × 38½]

67
Stairs, National Gallery,
London
1998

Oil on Japanese paper
Image size 144.8 × 97.8
[57 × 38½]

68
Demolition Site, Mill
Street, SE1
1996

Oil on linen
182.9 × 195.6 [72 × 77]

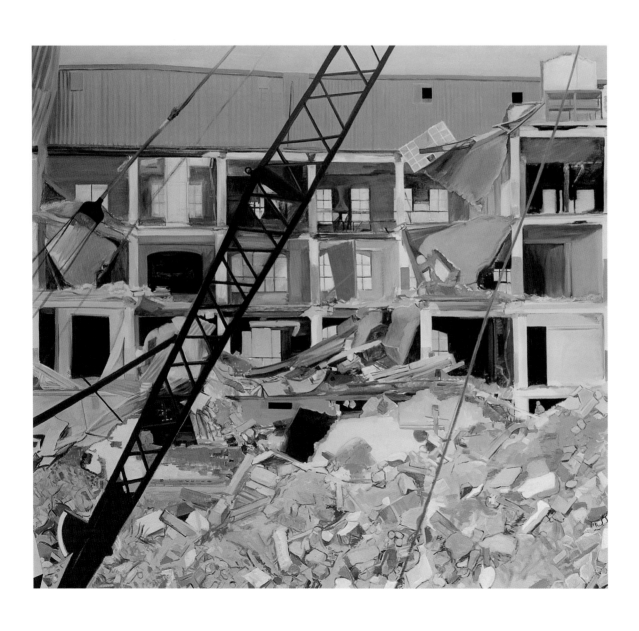

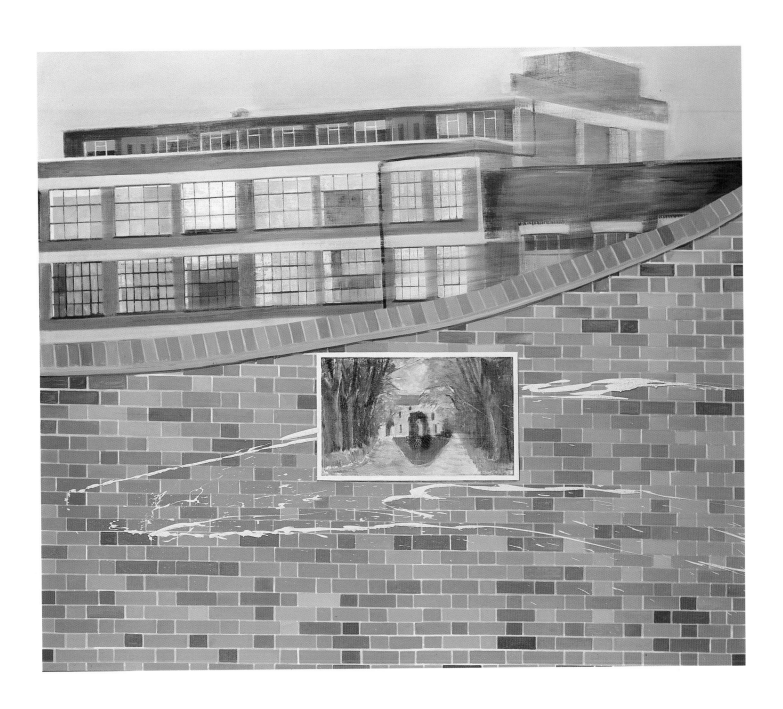

71
Enceinte I.M. GDS, KK
2001

Oil on linen
181.6 × 212.7 [71½ × 83¾]

70
Border
2000

Oil on linen
152.4 × 243.8 [60 × 96]

69
Mending Wall
2000

Oil on linen
152.4 × 243.8 [60 × 96]

74
Salthouse
2001

Oil and salt on linen
182×242.9 [$71\frac{5}{8} \times 95\frac{5}{8}$]

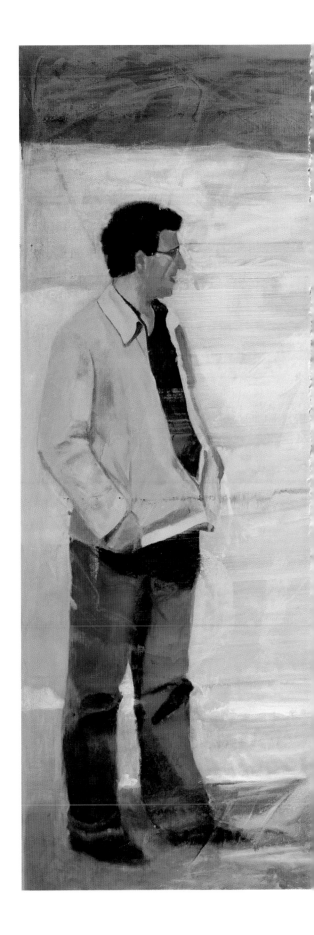

Envoy

About twenty-five years ago a lecture was given on Rothko by a new member of the art-history department at the college. It was wintertime, the light gone in mid-afternoon, and a large group of painting students gathered expectantly to receive insights into the great artist's work. After the tutor had swept the room and scattered water over the floor, those who remained sat and listened to the recorded voices of Robert Frost and T.S. Eliot reading their poetry. As the darkness thickened, the slow dissolution of vision and the poets' sonorous tones created a sense of weightlessness. Gravity seemed suspended as Frost described a boy's swinging in birch trees and apple-picking, and Eliot intoned from 'Ash Wednesday': "Who walked between the violet and the violet/ who walked between/ The various ranks of varied green …". The few who were left by this time were indivisible in the tenebrous, cloistral space. The tape ended; the tutor, with the aid of a cigarette lighter, read from the 'Four Quartets': "O dark dark dark. They all go into the dark,/ The vacant interstellar spaces, the vacant into vacant …". Nothing else has taught me to see better Rothko's clouds of colour floating into, above, beneath one another, light becoming shadow becoming form. And not only Rothko.

In his story *The Knight and Death* the Sicilian author Leonardo Sciascia writes: "Arches make the heavens more lovely, in the words of the poet. Do colonnades make cities more civil?" For the painter, the question is: can the depiction of the human form still be a true test of the world's measure, whereby everything can be defined, loveliness, civility, cruelty, indifference … ? The littoral scene of *Salthouse* is, like *Pier*, a celebration of friendship. Only with friends can the manipulation of their appearance be made with impunity in the higher service of pictorial efficacy. As opposed to Rothko, who in 1958 "found the figure could not serve my purposes … a time came when none of us could use the figure without mutilating it". Such compunction is rare in a time when the body is regarded as an entity worth less than the sum of its parts, when mutilation is so common a form it has become hackneyed. Painting, with its disinterested ebb and flow, opacity and translucence, can restore the sense of the whole to the part, reconstitute the strewn shards of a fast, unreflective world, the better to see its crazed aspect. In order to serve his purposes, the painter, "celebrating the marriage of flesh and air", sea and stones, makes them miscible with pigment, oil and varnish.

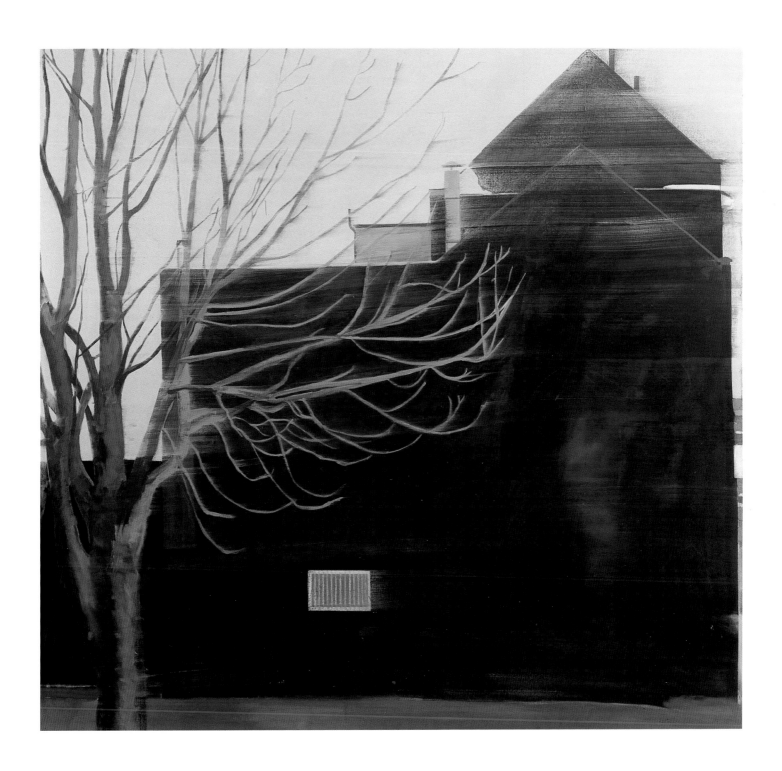

73
Château Noir, E3
2001

Oil on linen
182.9 × 195.6 [72 × 77]

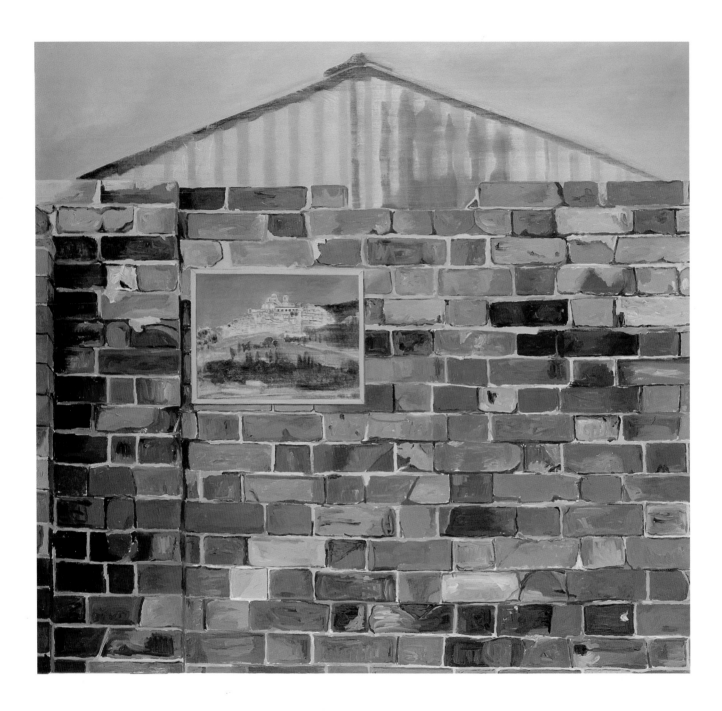

72
Refuge
2001

Oil on linen
182.9 × 195.6 [72 × 77]

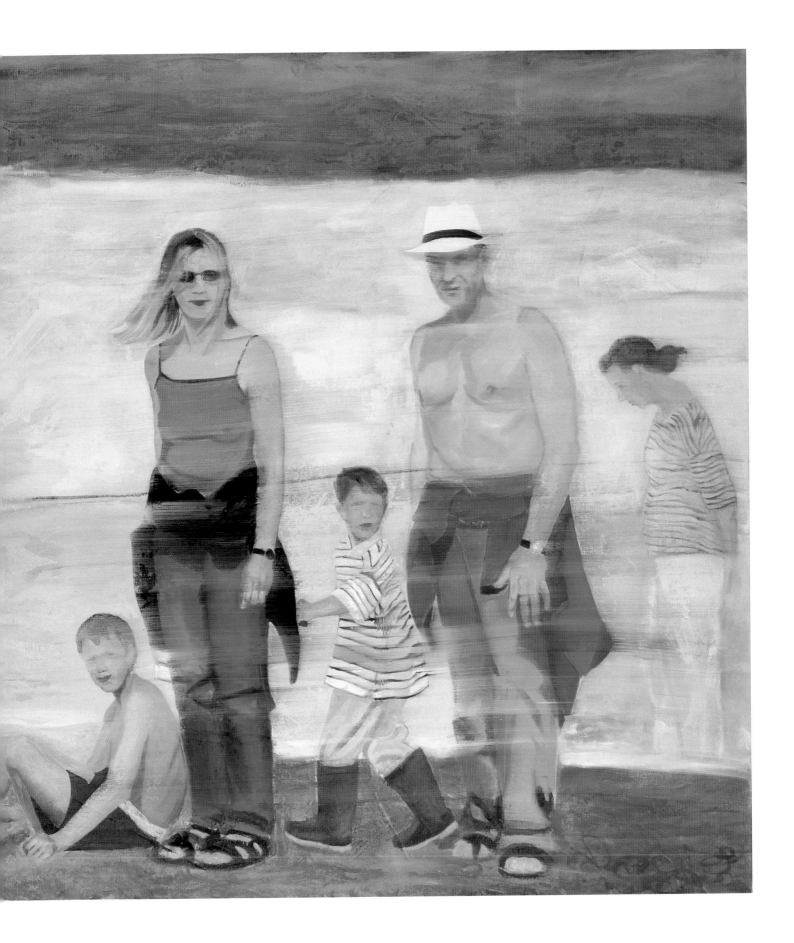

Checklist

1
Sudarium: Kafka
1986
Oil on jute
95.2 × 95.2 [37½ × 37½]
Collection of Caroline Porter

2
Sudarium: Baudelaire
1986
Oil on jute
96.5 × 91.4 [38 × 36]
Collection of Alistair and
Rebecca Hicks

3
Shroud
1987
Oil on linen
203.2 × 166.3 [80 × 65½]
Collection of Anthony Calder

4
Pall: After John Donne
1987
Oil on linen
213.3 × 97.8 [84 × 38½]
Collection of Alistair and
Rebecca Hicks

5
Pall: Ixion
1987
Oil and wax on linen
213.3 × 97.8 [84 × 38½]
Walker Art Gallery, National
Museums and Galleries on
Merseyside

6
Carphology: Tenebrae
1988
Oil on linen
152.4 × 127 [60 × 50]
Private collection

7
The Cumaean Sibyl
1988–89
Oil and wax on linen
214.6 × 98.4 [84½ × 38¾]
Collection of Mr and Mrs Richard
Cotton

8
The Shroud of Penelope
(Rove)
1988
Oil on linen
177.8 × 88.9 [70 × 35]
Private collection

9
Untitled
1988–89
Oil on linen
210.2 × 98.4 [82¾ × 38¾]
Collection of the artist

10
Nessus: the arrow bred
in the bone
1988–89
Oil and wax on linen
214.6 × 98.4 [84½ × 38¾]
Collection of Mr and
Mrs B. Spurrier

11
Mnemosyne
1989
Oil and wax on linen
205.7 × 80 [81 × 31½]
Collection of the artist

12
Via Roma, Turin
1990
Oil and wax on linen
148.6 × 200.2 [58½ × 78⅝]
Collection of David Burnett

13
St Paul de Mausole
1990
Oil and wax on linen
207.6 × 145.4 [81¾ × 57¼]
Private collection

14
San Marco, Venice
(Acqua Alta)
1991
Oil on linen
200.6 × 198.1 [79 × 78]
TI Group

15
Beckmann
1990
Oil and wax on linen
168.9 × 96.5 [66½ × 38]
Collection of Jayne Purdy and
Stephen Rubin

16
Cézanne
1989–90
Oil and wax on linen
168.9 × 97.8 [66½ × 38½]
Collection of Allen Baharaff

17
Degas
1990
Oil and wax on linen
168.9 × 97.8 [66½ × 38½]
Leicester City Museums Service

18
Malevich
1990
Oil and wax on linen
168.9 × 97.8 [66½ × 38½]
Private collection

19
Matisse
1990
Oil and wax on linen
168.9 × 97.8 [66½ × 38½]
Collection of the artist

20
Monet
1990
Oil and wax on linen
168.2 × 97.8 [66¼ × 38½]
Private collection

21
Munch
1990
Oil and wax on linen
168.9 × 90.1 [66½ × 35½]
Private collection

22
Picasso
1990
Oil and wax on linen
170.2 × 99 [67 × 39]
Diamond Trading Company
Collection

23
Bather
1990
Oil and wax on linen
186.4 × 91.8 [73⅜ × 36⅛]
Collection of the artist

24
Portrait of Jan Di Stefano
1991–92
Oil on linen
194.3 × 97.5 [76½ × 38⅜]
Collection of Penny Mason and
Richard Sykes

25
Arcadia
1989
Oil and wax on linen
208 × 151.7 [81⅞ × 59¾]
Collection of Siobhan and
Alexander Dundee

26
Tuileries Gardens, Paris II
1991
Oil on linen
189.8 × 144.1 [74¾ × 56¾]
Collection of Ingrid Gottschalk

27
Tuileries Gardens, Paris III
1991–92
Oil on linen
152.4 × 243.8 [60 × 96]
Private collection

28
Studio II
1991
Oil on linen
144.1 × 197.5 [56¾ × 77¾]
Private collection

29
Contre-Jour, Barcelona
1991
Oil and wax on linen
205.7 × 175.2 [81 × 69]
ITIM Associates, London

30
Place des Vosges, Paris
1991
Oil on linen
203.8 × 161.3 [80¼ × 63½]
Private collection

31
Studio V
1992
Oil on linen
152.4 × 243.8 [60 × 96]
Private collection

32
Studio III
1991–92
Oil on linen
152.4 × 243.8 [60 × 96]
Private collection

33
Sicilian Avenue, London
1992
Oil on linen
165.1 × 207.6 [65 × 81¾]
Collection of David Burnett

34
Montelimar I
1992
Oil on linen
189.8 × 144.1 [74¾ × 56¾]
Christie's Corporate Collection

35
In Transit
1992
Oil on linen
187.9 × 132 [74 × 52]
Private collection

36
Bonito
1994
Oil on linen
167 × 197.8 [65¾ × 77⅞]
Collection of Anne Burnett

37
William Brown Street,
Liverpool
1994
Oil on linen
167 × 197.8 [65¾ × 77⅞]
Private collection

38
Crucifix Lane, SE1
1996
Oil on linen
148.6 × 200 [58½ × 78¾]
Deutsche Bank

39
South Bank
1994
Oil on linen
181.6 × 212.7 [71½ × 83¾]
Museum of London

40
Orange Street, WC2
1994
Oil on linen
167 × 202.5 [65¾ × 79¾]
Collection of the artist

41
Hotel Splendide
1994
Oil on linen
182.9 × 213.3 [72 × 84]
Government Art Collection

42
Royal College Street, NW1
1994–95
Oil on linen
152.4 × 207 [60 × 81½]
Private collection

43
Marriage Portrait: John
Goto and Celia Farrelly
1994
Oil on linen
203.2 × 114.3 [80 × 45]
Collection of the artist

44
Sir Richard Doll
1996
Oil on linen
50.8 × 40.6 [20 × 16]
National Portrait Gallery, London

45
Waterloo
1994–95
Oil on linen
167 × 202.5 [65¾ × 79¾]
Collection of Dr Marion and
Mr Barrie Liss

46
London, EC2
1995
Oil on linen
190.5 × 221 [75 × 87]
Barclays Art Collection

47
Italian Cast Room,
Victoria and Albert
Museum (Laocoön)
1995
Oil on linen
152.4 × 207 [60 × 81½]
Collection of the artist

48
Neil Addison
1996
Oil on linen
154.9 × 97.8 [61 × 38½]
Collection of Neil Addison

49
Counterproof of Neil
Addison
1996
Oil on Japanese paper
Image size 154.9 × 97.8
[61 × 38½]
Private collection

50
Penguin House
1997
Oil on linen
170.2 × 221 [67 × 87]
Private collection

51
Adytum
1997
Oil on linen
118.1 × 163.2 [46½ × 64¼]
Private collection

52
Adit (Camera Obscura)
1997
Oil and graphite on linen
157.5 × 208.3 [62 × 82]
Private collection

53
Muleta
1997
Oil on linen
73.6 × 55.9 [29 × 22]
Collection of Alex Woodthorpe

54
Veronica
1997
Oil on Japanese paper
Image size 73.6 × 55.9
[29 × 22]
Private collection

55
Stairs, Provence
1995
Oil on linen
203.2 × 121.9 [80 × 48]
Private collection

56
Camera Lucida
1997
Oil on linen
157.5 × 208.3 [62 × 82]
Collection of the artist

57
Stedelijk Museum,
Amsterdam
1996
Oil on linen
203.2 × 137.1 [80 × 54]
Collection of the artist

58
85 Rokin, Amsterdam
1997
Oil on linen
203.2 × 121.9 [80 × 48]
Collection of the artist

59
Nice
1997
Oil on linen
60.9 × 71.1 [24 × 28]
TI Group

60
Mirage
1997
Oil on Japanese paper
Image size 60.9 × 71.1
[24 × 28 in]
Collection of Mr and Mrs Andrew
Whipp

61
Passage
1998
Oil and wax on linen
163.2 × 118.1 [64¼ × 46½]
Private collection

62
Limen
2000
Oil on linen
162.5 × 116.8 [64 × 46]
Collection of the artist

63
Pool of London
1998
Oil on linen
151.1 × 212.1 [59½ × 83½]
Collection of Dr Marion and
Mr Barrie Liss

64
Coram's Fields
1998
Oil on linen
151.1 × 212.1 [59½ × 83½]
Collection of the artist

65
Pier
1998
Oil on linen
182 × 242.9 [71⅝ × 95⅝]
Private collection

66
Stairs, National Gallery,
London
1998
Oil on linen
144.8 × 97.8 [57 × 38½]
Deutsche Bank

67
Stairs, National Gallery,
London
1998
Oil on Japanese paper
Image size 144.8 × 97.8
[57 × 38½]
Private collection

68
Demolition Site, Mill
Street, SE1
1996
Oil on linen
182.9 × 195.6 [72 × 77]
Collection of the artist

69
Mending Wall
2000
Oil on linen
152.4 × 243.8 [60 × 96]
Collection of the artist

70
Border
2000
Oil on linen
152.4 × 243.8 [60 × 96]
Collection of the artist

71
Enceinte I.M. GDS, KK
2001
Oil on linen
181.6 × 212.7 [71½ × 83¾]
Collection of the artist

72
Refuge
2001
Oil on linen
182.9 × 195.6 [72 × 77]
Collection of the artist

73
Château Noir, E3
2001
Oil on linen
182.9 × 195.6 [72 × 77]
Collection of the artist

74
Salthouse
2001
Oil and salt on linen
182 × 242.9 [71⅝ × 95⅝]
Collection of the artist

Pages 2–3
San Rocco, Venice
1990
Oil and wax on linen
166.3 × 196.8 [65½ × 77½]
Collection of Mr and Mrs J. Farmer

Page 8
Red Cloth
1994
Pastel on paper
76.2 × 56.5 [30 × 22¼]
Private collection

Page 34
The Waters of Leman
1990
Colour woodcut
Image size 182.9 × 121.9
[72 × 48]
Collection of the artist

Page 76
Pharos
1999
Oil on Japanese paper
Image size 152.4 × 167.6
[60 × 66]
Collection of the artist

Biography

Arturo Di Stefano was born in 1955 in Huddersfield, West Yorkshire, of Italian parents. As a child he lived with his maternal grandparents in the village of Bonito in Italy for two years before being brought back to England to live in Liverpool. After completing his foundation course at Liverpool Polytechnic, he left in 1974 to study fine art at Goldsmiths College and the Royal College of Art, both in London. With the exception of a year spent at the Accademia Albertina in Turin on an Italian Government Scholarship (1985–86) he has continued to live and work in London.

Recent solo exhibitions include *Portrait of a City: The London Paintings of Arturo Di Stefano* (Museum of London, 2000) and *Strands* (Purdy Hicks Gallery, London, and the Djanogly Gallery, University of Nottingham, 1998–99). A retrospective of his work was held at the Walker Art Gallery in Liverpool in 1993.

His work can be found in many public collections, including the Arts Council (Print) Collection, London; Chelsea and Westminster Hospital, London; Contemporary Art Society, London; Government Art Collection, London; Museum of London; National Portrait Gallery, London; Ferens Art Gallery, Hull; Walker Art Gallery, Liverpool; Harris Museum and Art Gallery, Preston; Leicester City Museums and the Victoria and Albert Museum, London.

Selected Bibliography

Exhibition catalogues

2000
Portrait of a City: The London Paintings of Arturo Di Stefano, exhib. cat. by Mireille Galinou, with notes by the artist, London, Museum of London

1998
Arturo Di Stefano: Strands, exhib. cat. by Nicholas Alfrey and Michael Hofmann, Frankfurt, Nottingham and London

1995
Arturo Di Stefano, exhib. cat. by Christopher Lloyd, Warwick, Preston, Leicester and London

1993
Arturo Di Stefano: A Retrospective, exhib. cat. by Alex Kidson, Liverpool, National Museums and Galleries on Merseyside

1991
Arturo Di Stefano, exhib. cat. by Yehuda Safran, London, Pomeroy Purdy Gallery

1989
Arturo Di Stefano: Paintings and Woodcuts, exhib. cat. by Andrew Brighton and Alistair Hicks, London, Pomeroy Purdy Gallery

General references

JAMES HAMILTON
Wood Engraving and the Woodcut in Britain, 1890–1990, London (Barrie & Jenkins) 1994

ALISTAIR HICKS
The School of London: The Resurgence of Contemporary Painting, Oxford (Phaidon) 1989

MICHAEL HOFMANN
Behind the Lines: Pieces on Writing and Pictures, London (Faber & Faber) 2001